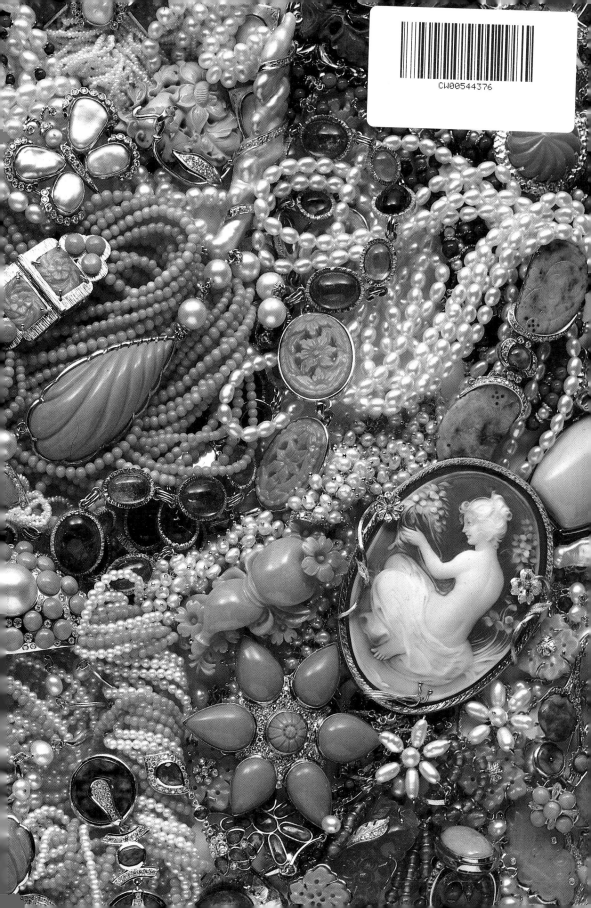

CLAUDE MAZLOUM

JEWELLERY AND GEMSTONES

An Investor's and Connoisseur's Guide

GREMESE
INTERNATIONAL

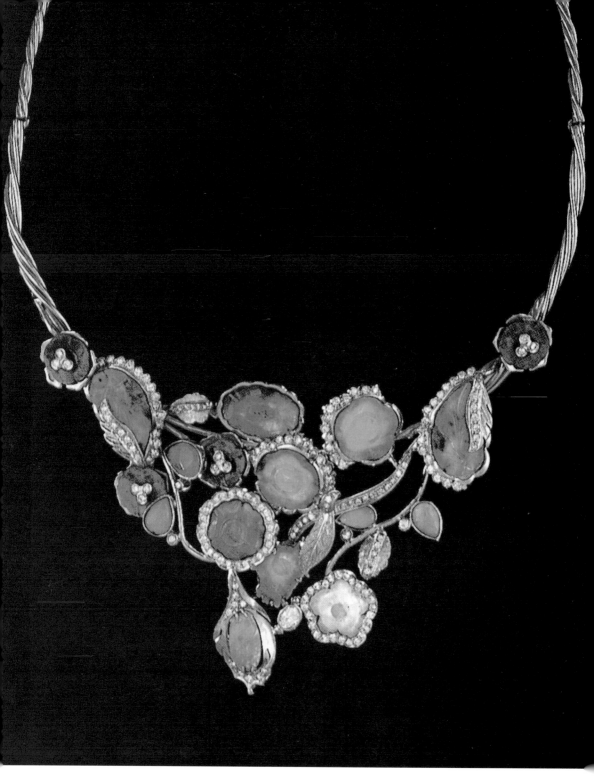

Jewellery is not, and rightly so, a consumer item, but a cultural asset,
a personal ornament and an expression of the wearer's personality.
Nuccia Joppolo Amato

Table of Contents

Cover photograph: "Octopus" bracelet created by Casa Damiani, the internationally famous jewellers, winner of seven oscars at the Diamonds International Awards. This bracelet is a rare combination of precious metals and minerals such as yellow gold, platinum and slate, built layer upon layer in perfect symmetry and studded with no fewer than 772 diamonds. World Jewellery Oscar 1990/91.

Inside cover: This exceptional display of jewellery is part of a collection created by Nuccia Joppolo Amato, the famous Milanese designer for whom this profession is not merely another form of art but a heartfelt passion.
Pag.2: A dream come true. Chinese jade and gold are matched in this unique design by Nuccia Joppolo Amato.
Back jacket photo: Gold ring by Moraglione of Valenza with diamonds and baguettes in an invisible setting. The workmanship is outstanding.

Translation of I gioielli e le pietre preziose
Translated by Shula Curto
Edited by P.E. Fogarty
Jacket design by Silvia Notargiacomo
Phototypeset by Graphic Art 6, Rome
Photolithography by Studio Bondani, Rome
Printed and bound by Industrie Grafiche Cattaneo S.p.A. - Bergamo

ISBN 88-7301-005-9

© 1990 GREMESE EDITORE s.r.l., Rome
English translation copyright
© 1991 by Gremese International s.r.l.
Casella postale 14335 - 00149 Roma

Preface

I must admit that this book came as a great surprise to me.

Mainly because it is the first time that a professional goldsmith and jeweller has written an in-depth account of his trade for the amateur rather than the expert. I was also surprised by the considerable amount of technical information it contains, which must have meant many hours of painstaking background research. It is a book that cannot fail to fire *the imagination of its readers, even those who know little or nothing about this fascinating subject, and in this respect it is indeed an innovation.*

Claude Mazloum, gemmologist and goldsmith, reveals the secrets of a time-honoured tradition. He introduces his readers to every aspect of his trade, from the science of minerals and precious metals and their processing to the art of jewellery making.

He comments on mining locations and techniques and includes a few well-chosen hints on how and where to set about buying gemstones. In other words, this is the complete guide for connoisseurs and enthusiasts alike. It is beautifully illustrated throughout with drawings, tables, black and white and colour photographs.

It is a book we have been waiting for for a long time.

Alfred Peth
*First President and Curator
of the Heimatmuseum in Idar-Oberstein.*

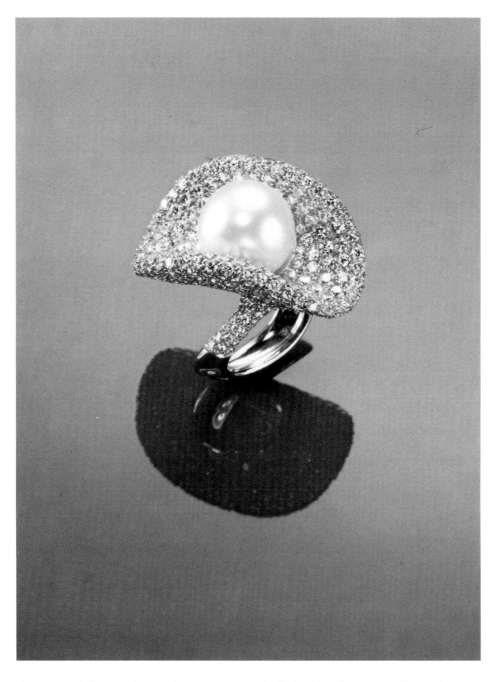

An unusual diamond and platinum ring embellished by the exotic allure of a rare "South Seas" pearl. By Mikawa of Casa Damiani.

Introduction

The ability to recognise precious stones is a highly specialized, complex science which can only be mastered by years of study and experience. Nonetheless, certain basic guidelines are within the grasp of us all, and with just a little practice anyone can learn how and where to purchase a precious stone at the best possible conditions.

The scope of this book is not just to help you to buy jewellery and precious stones, but also to show you how to wear them and offer them as gifts.

In the first place, do not let anyone influence you. The world is full of jewellers who would just love to sell you an old stone or left-over stock, or purchase at some ridiculously low price one of your most prized possessions. You must have total confidence in what you are doing, and do it according to certain basic rules of the trade. Ignore the innocent (and often irresponsible) suggestions of incompetent friends and of profit-minded jewellers, especially, who are quick to perceive hesitation and inexperience and turn the situation to their advantage.

This is not what you would describe as a literary or scientific book, but it is clear, which in my opinion is an essential prerogative for any handbook. And it will provide you with enough basic knowledge to be able to tackle virtually any transaction. In short, I could have called this book "How not to be swindled"!

Some information might at first glance appear to have little to do with the subject in question, but will in the long run make buying jewellery far more enjoyable, which sounds straightforward enough but is in actual fact quite an art. An entire chapter is dedicated to the art of wearing jewellery in order to maximize the effect on the beholder and enhance the wearer's own pride and pleasure. Another speculates on future trends in the jewellery trade.

Claude Mazloum

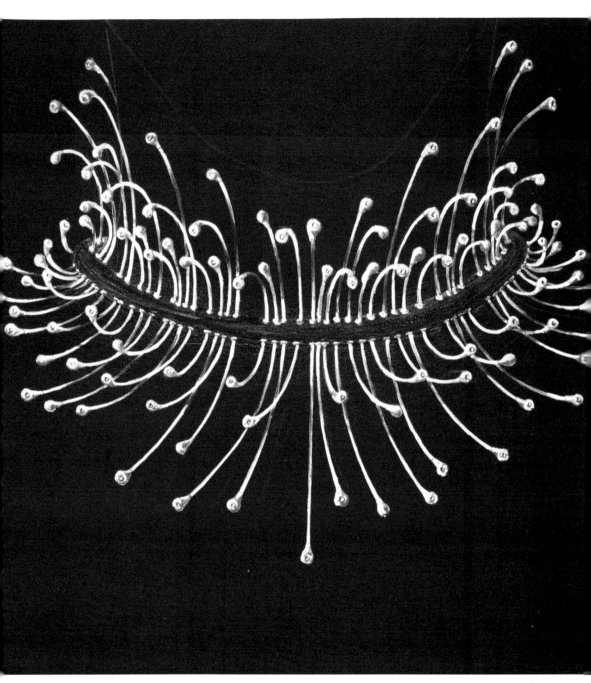

A sketch by Professor Rodolfo Santero for the creation of an ultra-modern style necklace.

The ABC of Professional Terminology

Before you even begin to consider buying jewellery or gemstones there is one most important thing to remember: in order to make a satisfactory transaction you must be able to negotiate on equal terms. Though at the early stages the conversation is merely a pretext to determine the competence of the parties involved. Some jewellers are masters in the art of intimidation. As soon as the un-suspecting customer, who has simply come for advice, sets foot in-side the shop, he is bombarded with a volley of questions astutely designed to heighten his feeling of discomfort. Having temporarily silenced his customer, the salesman, a winning smile on his face, begins his manoeuvre. Out of the display cases comes an endless stream of dazzling jewels which leave the "victim" gasping for breath. This is the moment our salesman has been waiting for to strike the final blow, and in reality it is he who chooses for the customer, from whatever merchandise he wants.

But when the salesman himself becomes a buyer, what a change we see! Now the aim of our subtle-minded friend is to quickly gain the upper hand, to the extent that the poor supplier, his inferiority complex growing with every minute that passes, has but two alter-natives: withdraw defeated or sell at some absurdly low price. Lucki-ly for us, salesmen such as the one I have described are becoming few and far between nowadays, for the simple reason that licences are no longer granted to the non-professional.

My advice, nonetheless, is to learn the terms of this profession. Do not hesitate to use them whenever necessary, if only to impress upon your "opponent" that you are not quite as naive as he would like to believe. If he is honest, he will respect your knowledge; if he is not, he will at least think twice about tricking you.

Adamantine Referred to diamond: pure, brilliant of impregnable hardness.

Amorphous An uncrystallized substance.

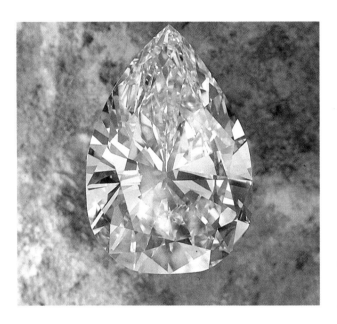

From the Latin adamas, *meaning invincible, is derived the term "adamantine" used to describe the brilliance, purity and hardness of a diamond. The diamond in the photo is of a pear-drop shape.*

Asterism An optical phenomenon characteristic of starstones when cut en cabochon, producing a six-rayed star shape within the stone.

Baguette A 25-facet rectangular cut with sharp corners.

Bead A stone cut in the shape of a small sphere.

Beryl A mineral species including emerald and aquamarine.

Brilliance The intense, sparkling brightness of a gemstone.

Brilliant A fine, round-cut diamond. You never have a rectangular or drop-shaped brilliant.

Cabochon Cut "en cabochon" means smoothly cut, without facets, into a domed shape.

Carat A measure of weight used for gemstones equivalent to 1/5 gram. The carat is divided into one hundred points. For instance, a 1/4 carat

stone would weigh 25 points, or 25 hundredths of a carat, or 0.25 carats.

Carat/Karat This has nothing to do with the previous definition. In this connotation it denotes the quality of gold, or the amount of gold in an alloy. A carat is one 24th part of a whole, therefore: 24 carat gold = 24/24ths = 100% pure gold. 18 carat gold = 18/24ths = 75% pure gold. 14 carat gold = 14/24ths = 58.5% gold.

Casing The metal setting that holds a gemstone in place.

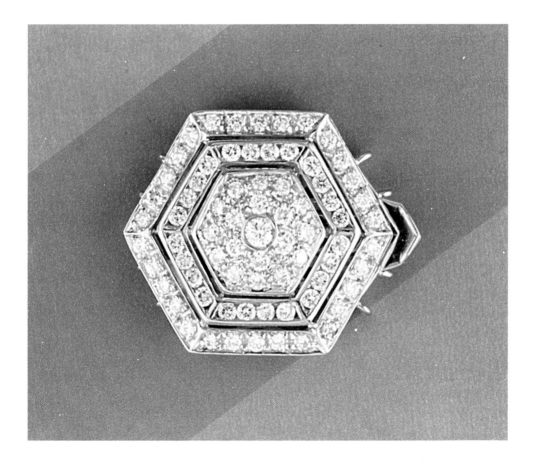

A white and yellow gold clasp set with brilliant-cut diamonds. By Deambrogio of Valenza, it is designed with three different types of setting: pavé, invisible, rub-over.

Ceylon	Gemmologists continue to use this name in reference to gemstones coming from the Republic of Sri Lanka.
Choker	A necklace of pearls of the same size.
Clasp	A fastening for jewellery, of especially fine work.
Claws	The part of the casing that secures the stone in place.
Cleaving	The term given to the division of a stone such as diamond into segments suitable for shaping into the final jewel. It is essential to determine the natural cleavage planes, for if these are not followed the whole stone may shatter into fragments.
Colour	In gemmology, colour is of prime importance. With diamonds we do not actually talk of colours, but nuances invisible to the naked eye. With coloured gemstones the meaning of the term is even more subtle, for in many cases it indicates the provenance of the stone.
Corundum	The mineral form of alumina. It includes the precious gemstones ruby, sapphire and yellow sapphire.
Crown	The upper part of a faceted stone. The large flat facet on the top of the stone is known as the table.
Cutting	The cutting, faceting and polishing of a rough stone. This is the work of the lapidary.
Diamond:	
White-white,	A diamond of no other nuance than white;
Blue-white,	A diamond of a very slight blue tint which, together with the pink, mauve, and red tinted gems is among the rarest; Commercial white, lightly tinted with yellow or brown; Cognac, softly tinted with a shade varying from light to dark cinnamon brown; Yellow, the paler shades are known as straw or champagne, the darker as canary or jonquil.
Emerald cut	The most popular cut for an emerald. It is rectangular with bevelled corners. A diamond cut in this shape is called an "emerald cut diamond".

Fire	The brilliance and luminosity of a gemstone.
Flat setting	A setting of gemstones close together like the stones of a pavement so that no metal cn be seen.
Garden	A term used in connection with emeralds which refers to the inclusions and fissures almost always present in this mineral, and which is vaguely reminiscent of vegetation.
Gem	A precious or semi-precious stone.
Geode	A nodular stone containing a cavity usually lined with crystals or mineral matter.
Girdle	The periphery at the widest part of a cut stone. The girdle of a faceted stone separates the crown from the pavilion, while the widest part of a cabochon cut stone is at the base.
Inclusion	A gaseous or liquid substance or small body contained in a crystal or mineral mass.
Kashmir	The name given to the finest coloured sapphire. It can also mean sapphire mine.
Loss	Difference in the weight of a metal before and after it has been worked.
Lot	A selection of stones grouped together according to similarities in color, purity, cut or other general characteristics.
Marquise	A pointed oval cut with 58 facets.
Matrix	The rock-mass surrounding a precious mineral. Also called gangue.
Melting down	Melting down gold objects in order to recover the precious metal for re-utilisation.
Mounting	A jewel in the work phase preceding its setting.
Orient	The peculiar lustre of a top quality pearl.
Parure	A set of jewels intended to be worn together.
Pavilion	The lower part of a faceted gemstone.The tiny facet at the undermost tip of the stone is called a culet
Pear drop	A pear-shaped jewel used as a pendant.
Pectoral	In ancient times, a gem-encrusted piece of cloth extending over the chest area. Today, this term describes a wide necklace that covers the body between breast and neck.

Pigeon blood red	The finest colour of ruby.
Phenomenal stones	Stones so-called because they have particular optical effects, for instance cat's-eye or starstones.
Piqué	The name given to the black and white inclusions in a transparent gemstone, especially diamond. They are visible to the naked eye.
Purity	The degree of purity or clarity of a gemstone is determined by close examination with a jeweller's loupe or magnifier. Number, size and nature of inclusions within the stone are thus established. A gem is considered "loupe clean" if no inclusions are present.
Ray	The silky lustre of a cat's eye or tiger's eye which, when the stone is held to the light, resembles the contracted pupil of a cat's eye.
Refined gold	Pure gold. Eighteen carat gold is a gold alloy.
Rubover setting	Covering the periphery of a stone.
Schiller	A peculiar lustre characteristic of certain minerals when the crystal is turned in different directions.
Siam	The name by which gemmologists still refer to Thailand.
Silk	A series of gaseous or crystalline inclusions found in corundum (ruby and sapphire) and forming a kind of veil that sometimes prevents the light from reflecting. On the smooth surface of a cabochon cut stone, such as starstones, these silks create an optical effect.
Solitaire	A precious stone, often a diamond, set by itself.
Square cut	A square cut gem with sharp corners.
Stone	Coloured stone, a precious gemstone, except diamond; Ornamental stone, a stone used for making ornamental objects. It may also be used for fancy coloured jewellery; Precious stone (there are only four): diamond, ruby, emerald and sapphire. All the others are semi-precious stones; Rough stone, a stone in its natural state before

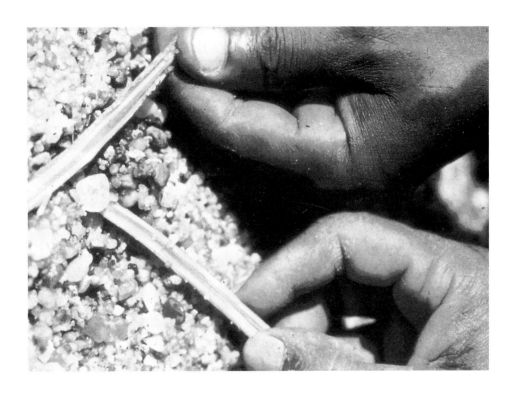

*Rough
diamonds in
their natural
state.*

*Sorting rough
diamonds at De
Beers in London.*

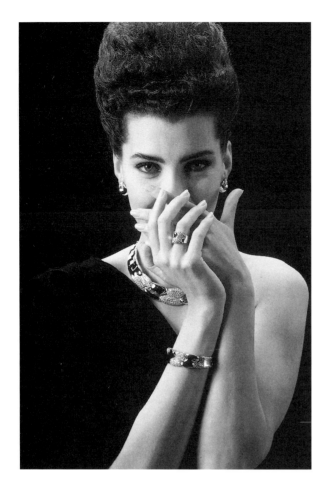

From Casa Damiani a parure in gold platinum and diamonds

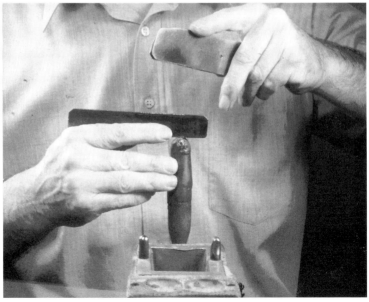

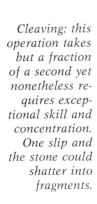

Cleaving: this operation takes but a fraction of a second yet nonetheless requires exceptional skill and concentration. One slip and the stone could shatter into fragments.

cutting; semi-precious stone, any natural gemstone, apart from the four precious stones; Synthetic stone, man-made stones having the same physical properties as the natural stone. They can be distinguished by the types of inclusions they contain.

Title The expression in carats of the degree of purity of gold, which means the percentage of pure gold contained in an alloy. For instance, 18 carat gold is 75% pure gold. All gold articles must bear the maker's hallmark stating the standard of the metal.

Translucent Semi-transparent, allowing the passage of light but diffusing it.

Vein A deposit of metallic or crystalline material having an extended or ramifying course underground.

Vermeil Gilded silver.

Water The lustre and transparency of a gem. A gem is considered of the finest or first water when it is so pure that it seems to contain a transparent liquid.

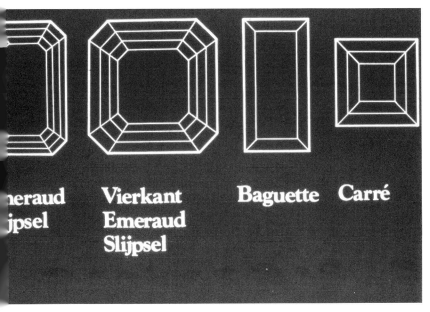

neraud **Vierkant** **Baguette** **Carré**
jpsel **Emeraud**
 Slijpsel

Different types of square and rectangular cuts. Note the difference between the baguette and emerald cut.

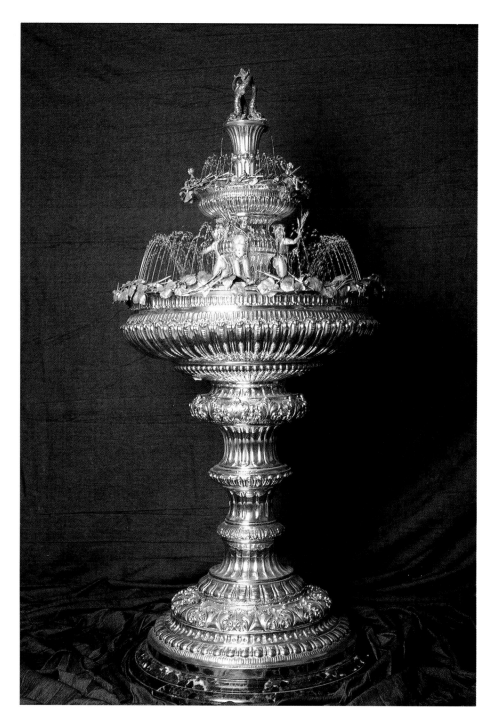

Silver is an essential part of the goldsmith's trade. This masterpiece is entirely hand-made by highly skilled craftsmen from a design by Melita Capuano of Capuano's of Via Veneto in Rome. The fountain, worthy of a palace of a Thousand and One Nights, contains 90 kg of silver and vermeil, is two metres high and took 14 months to make.

Part One

The Birth of a Jewel

Rare precious metals and gemstones are the essential elements of the art of jewellery making. These raw materials, once they have been extracted from beneath the earth's surface, are first refined then worked by experts. But they will pass through the hands of countless people of diverse races and social backgrounds before they are entrusted to the skill and integrity of the master craftsman for the final stages.

This chapter describes the principal phases in the transformation of these precious molecules into a work of art.

Precious Metals

Since time began, man has been fascinated by precious metals. Amongst these gold, silver, platinum, palladium, rhodium, osmium and ruthenium. But it is the exceptionally versatile characteristic of gold that make this the "noblest" of metals and the one most widely used in jewellery making. Firstly, it is a very dense metal (specific weight is over 70% higher than that of lead) but at the same time the most malleable and ductile. For instance, a mere gram of gold can be drawn into a continuous thread over three kilometers in length. From a chemical point of view, gold has only two enemies: mercury, a liquid metal with which it immediately forms a stiff amalgam, and aqua regia, a mixture of hydrochloric and nitric acids in which it readily dissolves.

This yellow metal is found mainly in Africa, South America and the Soviet Union, and to a lesser extent in North America and Australia. There are also a number of mines in Europe which yield a few hundred kilograms each year.

21

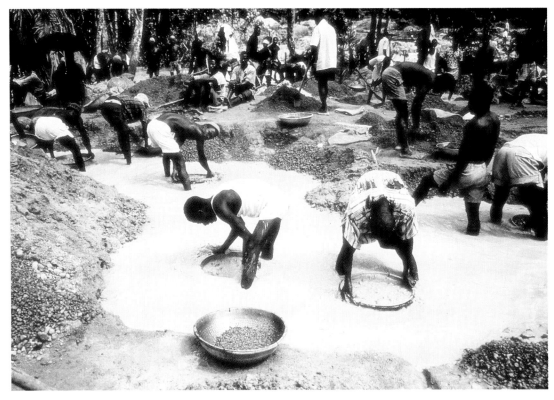

Panning for gold in Africa.

Gold ingots in a Swiss bank.

Fusing gold after refining.

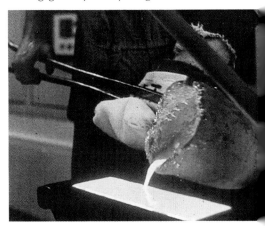

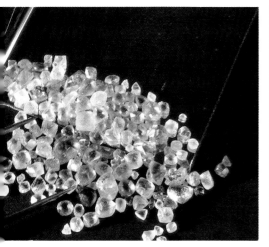

Rough diamonds.

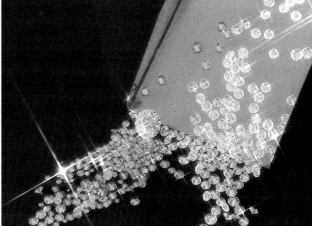

White and green brilliants.

Once the gold has been extracted and refined, it is then melted into crude bullion in the form of ingots or bars. Ingots have an average weight of 1 kilogram while bars can weigh up to 12 kilograms. The "standard ingot" weighs between 350-450 ounces and is the largest gold bar on the market. The troy ounce is equivalent to 31.1034807 grams.

Rough Stones

Have no illusions: you have to go to the ends of the earth to find them, for they are even rarer than gold! But without these precious gems there would be no jewellery, for the metal forms only the support. Right from the dawn of civilization, even before the discovery of metals, man has collected precious stones. In early times, they were used mainly for hunting and in battle, only the very finest being set aside for self-adornment.

Strange as it may seem, women have only been wearing jewellery for the last three thousand years. Before this time, men alone adorned their bodies, jewellery being considered a symbol of dignity. The more a man wore, the more he was held in consideration by the members of his tribe.

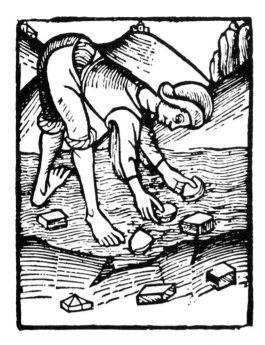

Once the rough stones have been sorted, they are then washed in acids before being sent to skilled workmen for cutting and polishing. Often this is carried out in villages close to the mine, but the more valuable stones are generally sent to specialized laboratories in the cities.

Prospecting for gemstones in the 15th and early 20th centuries.

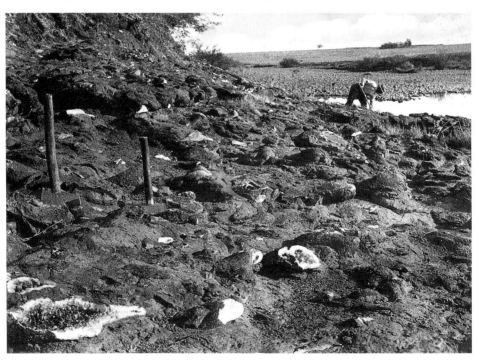

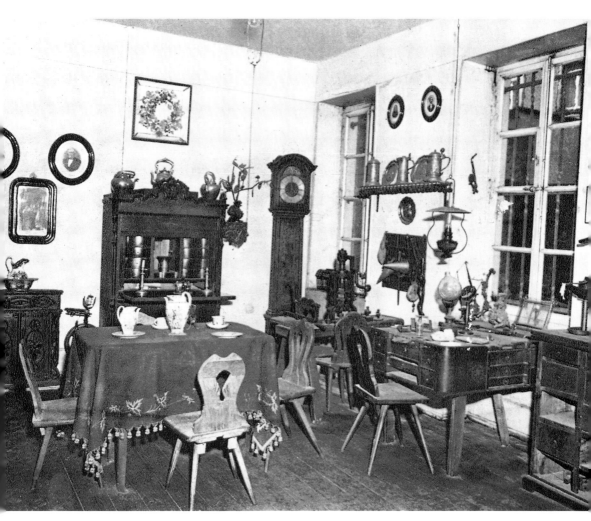

A lapidary's workshop in the 1850s.

Designing Jewellery

The first step in the creation of a piece of jewellery is to jot down ideas in the form of a rough sketch. From this is developed the final design from which the master craftsman will work.

In order to do this, a designer needs to know the number, size and type of stones to be used, the colour of the metal and, if possible, the purpose of the object he is about to create.

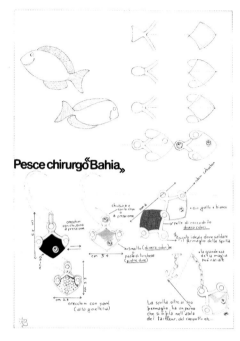

Filippo Biffani: Sketches for a necklace based on a fish motif.

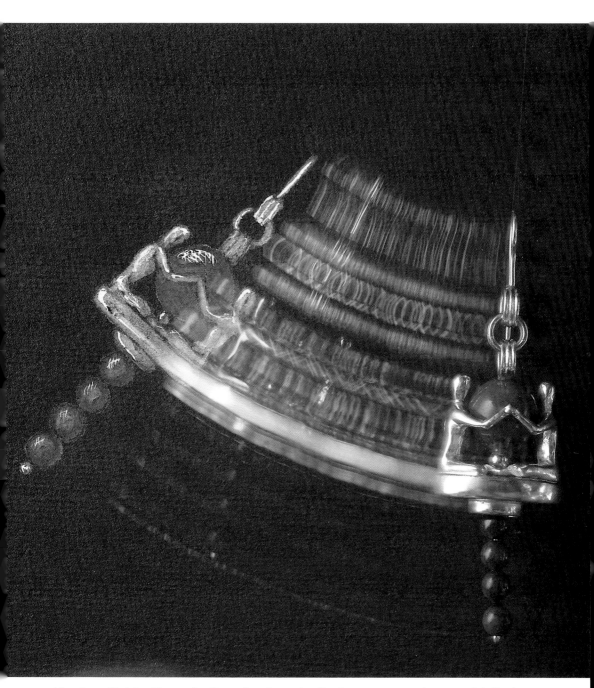

Massimo Aloisio. From the first sketch to the final ornament, a long road full of obstacles and surprises.

Deciding the Alloy

For most purposes it is desireable to increase the hardness and resistance of gold by alloying. This is achieved by combining the gold with varying amounts of other metals, depending on the percentage of gold required.

This phase is important because it fulfills the need for colour variations in the gold and for varying degrees of hardness and softness.

Alloying

In this phase the various components of the alloy are melted together into a homogeneous mass and cast into an ingot mould, resulting in a flat piece or square rod which can later be rolled into either a flat sheet or wire.

Rolling

This is a technique for transforming the ingot into sheets or wires. The metal is slowly pressed in a rolling mill to the desired thickness. Each time the metals pass through the steel cylinders of the roller they are heated to a very high temperature so that the molecules are restored to their original structure.

Fashioning

This implies the preparation of the many and varied components that go into the making of an ornament.

Some jewellery is composed of literally hundreds of parts, each of which, however small, requiring time, patience and meticulous workmanship. The slightest error could result in total disaster and considerable wasted effort.

Soldering

This is the technique of joining pieces of metal together into the desired shape.

It is achieved using a soldering torch, of which there are many different types, and is a delicate operation, though it need not be difficult provided a basic set of rules is followed.

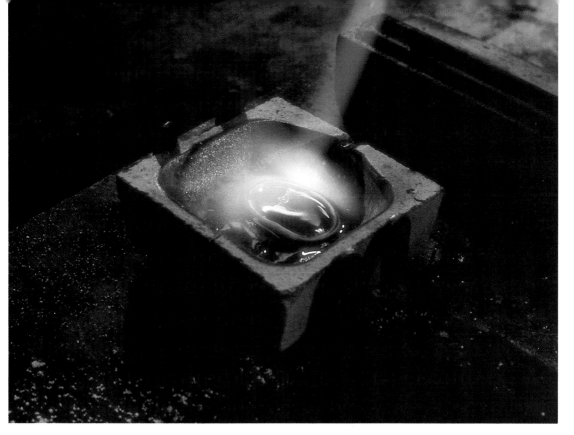

Melting gold in a crucible.

Filing

After soldering, the rough edges are smoothed or trimmed off by filing. Files come in a wide variety of shapes and sizes, each suited for a particular technique, for this can be extremely fine work. In some cases a small drill is used, similar to a dentist's drill. This is driven by a small electric motor fixed onto the work bench.

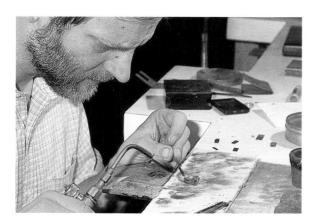
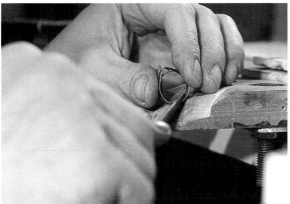

Soldering and filing.

Setter's workshop. The glass spheres provide the ideal light for this precision work.

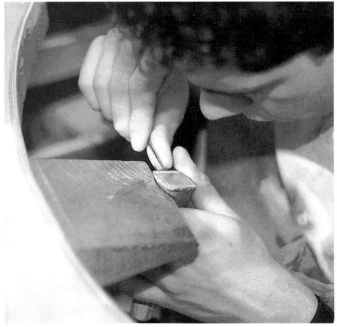

Apprentice setter practicing on copper.

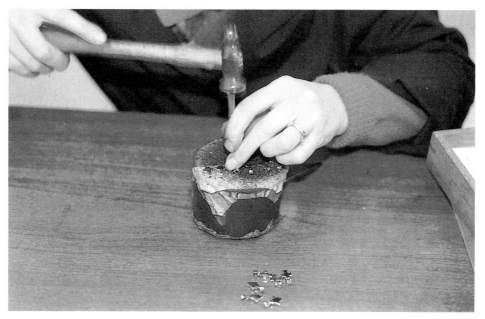

The art of embossing is one of the oldest techniques of the goldsmith's trade. It requires special skills and constant practice. Today, the master engravers who still use this technique are few and far between.

Emery Papering

The main purpose of emery paper is removal of file marks prior to polishing. It comes in a number of grades from coarse to very fine. The craftsman begins with a coarse grade paper gradually working down the scale until the metal has a smooth finished appearance. The gold dust resulting from this process is gathered up for further use.

Setting

The setter is the craftsman who fixes the stones into a setting or casing. Great care must be taken to apply the correct degree of pressure otherwise the stone may chip or fracture.

These craftsmen are generally of a calm, self-confident disposition and neither drink nor smoke.

31

Different types of settings

Invisible setting for square cuts

Rubover setting for baguette cuts

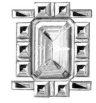

Mixed setting for square, baguette and emerald cuts.

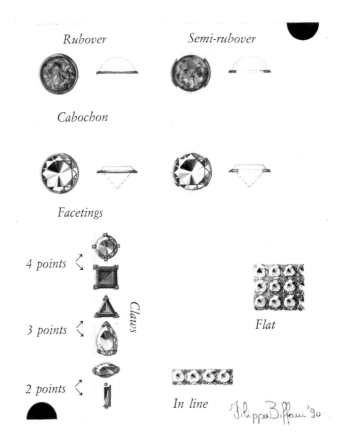

Rubover *Semi-rubover*

Cabochon

Facetings

4 points

3 points

Claws

2 points

Flat

In line

Polishing

This is the final stage in bringing a piece of jewellery to completion by imparting to the metal its characteristic patina. This is usually done by polishing mops and brushes of varying degrees of abrasion,

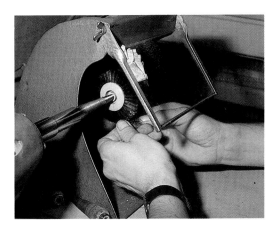

Polishing. The fine dust produced during this phase of work is undoubtedly valuable, but can be harmful if inhaled over any length of time.

used on the spindle of a polishing motor. The machine is complete with a special suction valve for removing the fine polishing dust which, however valuable, would be dangerous if inhaled for any length of time.

Initially a hard bristle brush is applied followed by a series of fabric and soft bristle mops in diminishing order of abrasion. There is also a mechanical method of polishing. The jewellery is placed in

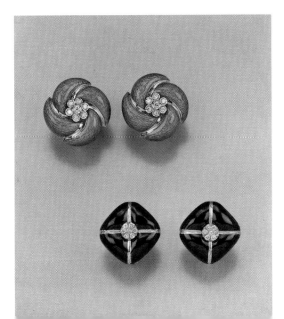

Enamelled earrings by Ermes Marega and Luciano Cortellazzi. The technique of enamelling provides designers with a wide variety of bright glossy colours from which to choose.

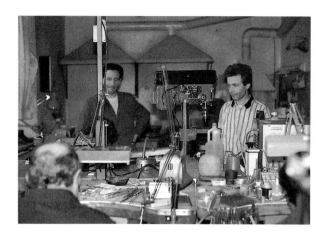

*Daily routine in a
jeweller's workshop;
a synthesis of peace
and quiet,
dynamism and
precision.*

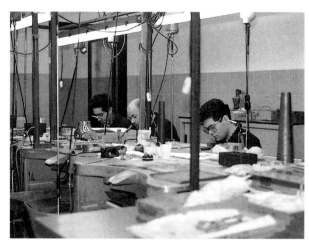

Moraglione's workshop at the turn of the century. The wooden framework on the floor was to prevent the gold dust from sticking to the craftsmen's shoes.

a small rotating drum containing little steel balls and a special soap. This operation takes several hours and gives only a superficial patina. It is far less effective than the traditional method.

In conclusion, I should perhaps point out that I have described here but a few of the techniques used in jewellery making. There are many others, less traditional maybe but none the less interesting. For instance lost wax casting, a process of reproducing one original piece into many multiples starting from a wax prototype. This technique follows the traditional method from the filing stage. Or die stamping, a mechanical process, similar to the minting of coins, of stamping out metals such as gold in relief. Or filigree, very popular in Middle and Far Eastern countries. It is made up of the most delicate wires, threads and beads which may also be enamelled.

The most important centres of jewellery making are found in Italy: Valenza Po, Vicenza and Arezzo. Some 335 tons of gold are worked in Italy every year, representing 21% of the output of the world goldsmithery trade and 64% of that of Europe (1989 estimate).

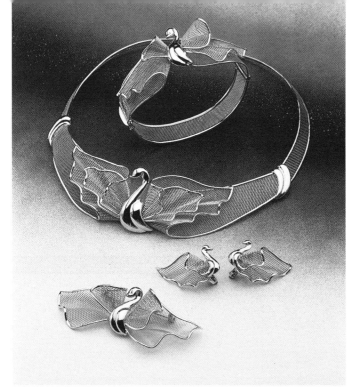

By Pavan a gold and platinum parure.

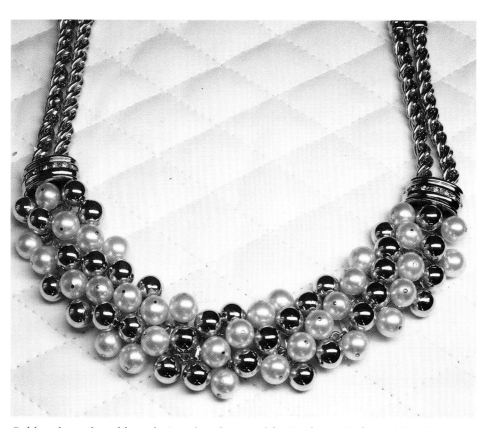

Gold and pearl necklace designed and created by Professor Roberto Mangiarotti.

The Four Precious Stones

With the cooperation of Charles Mazloum - Gemmologist

This entire book would not provide sufficient pages to describe the four precious stones to the full, so many and varied are their properties. Having said that, I will try to give as clear a description as possible in the brief space available, enough at least to enable readers to begin to understand and appreciate these wonders of nature.

Each of the four gemstones is dealt with separately, starting with the diamond, the hardest of the stones; next the emerald and lastly the two corundums, ruby and sapphire.

Diamonds

Diamonds have always exercised a special magnetism on the human race, the female of the species in particular. Their story, which I would describe as both romantic and social, is known the world over. Hardly surprising then that the diamond is the most popular gemstone of all.

Its chemical composition is simple: pure crystallized carbon referable to the cubic order of crystallography. It is formed in volcanic craters and dispersed by volcanic eruption or flooding.

There are two main varieties of diamond: mis-shapen crystals which have certain industrial applications and gem diamonds used in jewellery making.

Diamonds for industrial applications are coloured, opaque or impure. They are widely employed for drilling tools and precision instruments. Gem diamonds are pure and colourless, though the rare coloured transparent specimens are highly valued by the experts.

Working a diamond. Little has changed over the years and today's craftsman goes through much the same motions as his counterpart of yesterday.

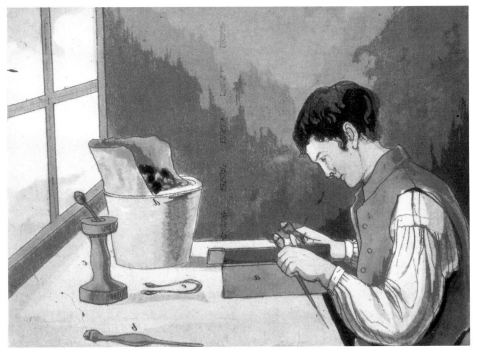

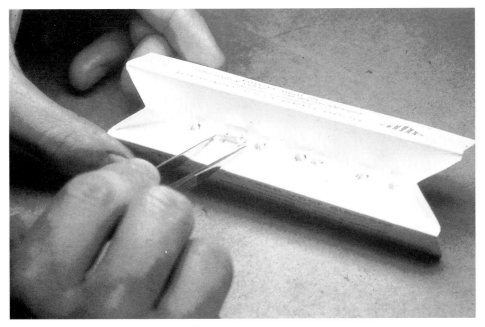

Verifying the colour of an emerald-cut diamond.

The hardness of the diamond is outstanding. It is, in fact, the hardest natural substance known to nature. It is listed at 10 on the Mohs scale of scratch hardness, this quality being judged according to the mineral's resistence to scratching by a pointed stone.

The colour of a diamond is of prime importance in establishing the quality of the gem. Off-white, shades of blue, pink and lilac are highly prized. We should use the term "blue white" with discretion, for stones that are truly worthy of this designation are very rare indeed, and only a handful of jewellers, dealers and collectors are lucky enough to own one. Shades of yellow (Cape series) and brown are far more common and less valuable. Albeit, a truly colourless, transparent diamond is the finest and most precious.

It is far from easy to determine the colour of a gemstone, but we do have a set of rules to help us. Above all, diamonds should not be examined in artificial light, or in a room where there is a play of light. A diamond best reveals its magnificence in a northern light or close to a window and ideally should be observed on a clear day between the hours of 10am and 1pm. The most efficient method is to place the stone upper side down on a sheet of white paper and from

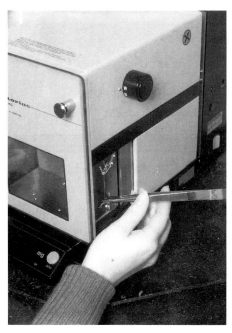
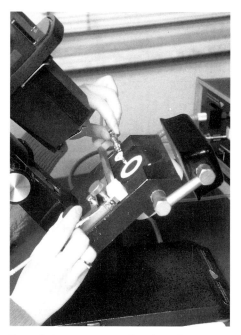

Weighing gemstones on an electronic balance.

Examining a stone under the microscope.

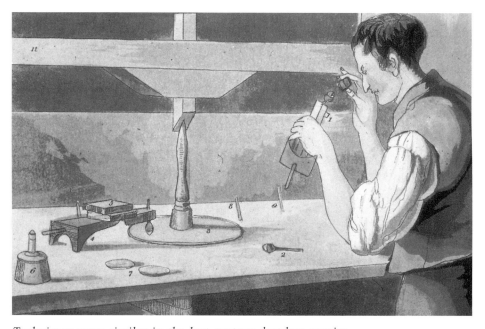

Techniques were similar in the last century, but less precise.

an oblique angle study the light reflecting through the facets of the base.

It goes without saying that if you are going to negotiate the price and quality of a stone, this operation is best carried out in the presence of an expert.

Do pay attention to this brief paragraph on impurities, for these surely undermine the value of a gemstone. Diamonds often contain inclusions, and these may be inspected with a microscope, jeweller's loupe or simply the naked eye. If no such inclusions are visible the stone is classified as "loupe clean".

Impurities in diamonds generally appear in the form of tiny black spots or whitish clouds, but there may also be fractures which will tend to enlarge dangerously. Far less frequent are inclusions of other minerals.

The cutting of a gemstone is extremely important. An expert cutter is able to bring out all the hidden brilliance of a gem, but he first has to overcome the problems brought about by its hardness. In fact, a diamond can only be cut by a diamond chip, according to specific techniques such as cleaving or sawing.

The most popular and probably the most beautiful cut for a gem diamond is the brilliant cut. This has 58 facets, of which 33 form the crown and the rest the base. The so-called girdle separating the two parts is often opaque and rarely faceted.

The single cut is used on very small stones and has 8 facets on the crown and 8 on the base. The rose cut, no longer fashionable today, consists of a flat base, with the crown cut into a number of triangular shaped facets.

The first diamonds were discovered in India around 800 B.C.,then in Brazil many centuries later in 1725. The legendary South African mines were not discovered until 1867. In 1908, mines were opened in South West Africa, in 1910 in Angola, the Ivory Coast and Tanzania. The most recent discoveries were in Russia in 1948.

Mining diamonds is no easy task. Some 300 tons of earth and rock must be sifted to recover 12 carats of rough diamond, which in the end will yield 1 carat of cut diamond. Many attempts have been made to imitate this mineral; most have failed. General Electric developed a process for the manufacture of diamond grit for industrial purposes. Then in 1970, a synthetic diamond was in fact produced, but the process was so costly that is was soon abandoned. It was found to be considerably cheaper to extract 1 carat of diamond from the earth!

Choosing a Diamond

There is a variety of different factors to consider when choosing a diamond, and every expert has his own ideas (or prejudices) to convey to a potentional customer. Personally, I give priority to the cut, for a badly-cut diamond, however pure, will have far less fire than a well-cut diamond with one or two impurities. In cutting a diamond it is essential to achieve the correct proportions and angles. The slightest mistake in this sense and the gem will be robbed of part of its brilliance. If too thickly cut the light will be reflected downwards and absorbed in the pavilion, as was the case in ancient usage. If the cut is too fine, the light will pass straight through the gem, as if through a piece of glass. When the correct proportions are achieved, the rays of light will instead be reflected in all directions and broken down into the colours of the spectrum, giving the gem its characteristic fire. The most effective cut for a diamond is the brilliant cut, but there are others which are just as beautiful; for instance baguette, marquise, trap or step cut, oval, emerald, triangular, heart-shaped, drop and many others. The baguette and triangular cuts have perhaps less brilliance; the former because it has only 25 facets, the latter because it has too many straight facets.

In my opinion, the next most important aspect is the colour of the gem. The guidelines here are hard to establish, for even a diamond expert will have difficulty in distinguishing a "finest white" from a "fine white". For this reason I would advise a certain degree of flexibility over choice of colour. Moreover, prices vary considerably from one grade to another. The important thing is that the gem is "white", and I would suggest making your choice from the F and G whites, which are quite reasonably priced in comparison with the two top grades. In other words, you would do far better to purchase a 2 carat G white diamond rather than spend the equivalent sum on a 1 carat D white gem. The optical effect is practically identical, but from the investment point of view I should remind you that today a large H grade gem is far easier to sell than a smaller D grade diamond of the same value.

In terms of coloured diamonds, it is important to choose those of a pure, dark shade (except pink, blue and lilac). Avoid indistinct and pale shades, especially those of a yellowish or brownish hue. Red, blue, green, canary yellow and pale yellow stones are instead highly prized.

Do not attach undue importance to the purity of a diamond. What

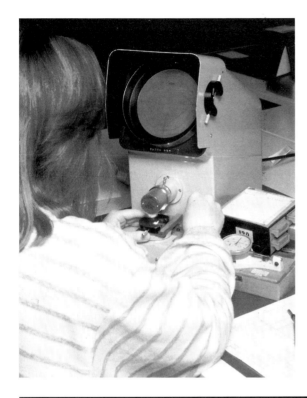

*Checking
proportions
and colours.*

43

Heaps of diamonds waiting to be sorted and assessed

you should take into account is the final destination of the gem. If it is going to be placed in a setting then it need not be flawless, for there are many inclusions that are virtually invisible to the naked eye, but they will lower the purchase price of the stone considerably. A loupe-clean diamond costs on average three or four times as much as a stone with a tiny flaw (one small inclusion S1), but the optical effect is the same, especially if the inclusion is in the pavilion or on one of the sides of the crown. If you do decide to buy a diamond with a flaw, I advise you to chose one with a white rather than black inclusion. In short, the ideal choice is a well-

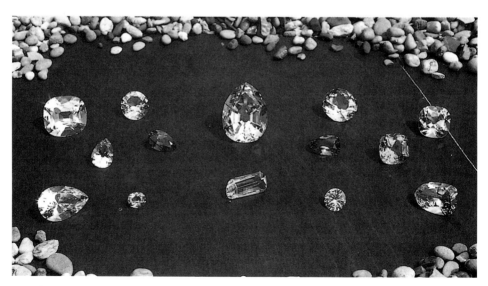

Synthetic copies of some of the world's most famous diamonds, on display at the Heimatmuseum in Idar-Oberstein.

cut, fine white (G) gemstone with one small inclusion. This, I can assure you, will provide the best "effect-quality-price" ratio.

Lastly weight. In actual fact, a stone weighing 1.9 carats has the same surface area as a 2 carat stone, but it is worth 10% less. If you are certain that you are going to keep the stone, then you could quite feasibly choose one that weighs a little less than a round figure (0.97, 1.49, 2.98 carats) thus making a considerable saving. If, on the other hand, you are buying for investment, then you would be wise to prefer a stone weighing a round figure or just over (1, 1.52, 3.01). It will be much easier to sell later on.

Suggestions for Setting a Diamond

A diamond is generally set as a solitaire. Traditionally, the setting was made of platinum or white gold, but a diamond is equally beautiful with yellow gold, especially if it is of a cinnamon or yellow shade.

If the diamond is not very big (less than one carat), the effect will be greatly enhanced if it is set with coloured gemstones. Very small diamonds are often used to make a surround for a larger diamond or coloured gemstone. Jewellery designers have devised numerous ways of raising centre stones with small drop cut or triangular shaped diamonds, using different types of setting.

Nature's most precious elements: the human body, gold and diamonds.

45

Terminology describing diamond inclusions

France	England	U.S.A.
Pure 10 fois/pure à la loupe	Loupe-clean/ internally flawless	LC/IF
Une très très petite inclusion	One very very small inclusion	VVS1
2 très très petites inclusion	2 very very small inclusions	VVS2
Une très petite inclusion	One very small inclusion	VS1
2 très petites inclusions	2 very small inclusions	VS2
Une petite inclusion	One small inclusion	SI1
2 petites inclusions	2 small inclusions	SI2
Un piqué	One piqué	P1
Piqué 2 fois	2 piqués	P2
Piqué 3 fois	3 piqués	P3

To determine clarity grade a stone is carefully examined with the aid of a 10x magnifier or jeweller's loupe.
A diamond is judged "loupe clean" when no inclusions are visible. From grade S12 upwards it becomes progressively more difficult to detect inclusions.

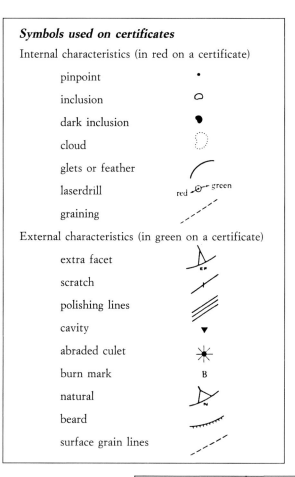

Symbols used on certificates

Internal characteristics (in red on a certificate)

 pinpoint

 inclusion

 dark inclusion

 cloud

 glets or feather

 laserdrill red green

 graining

External characteristics (in green on a certificate)

 extra facet

 scratch

 polishing lines

 cavity

 abraded culet

 burn mark B

 natural

 beard

 surface grain lines

Diamonds:
most popular cuts

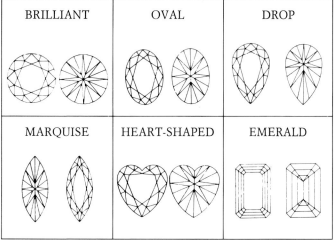

BRILLIANT	OVAL	DROP
MARQUISE	HEART-SHAPED	EMERALD

Table of the principal terms used to describe the colour of diamonds

Antwerp	France	H.R.D.*	England	Scandinavia	U.S.A.
0 +	Blanc exceptionnel +	Exceptional white +	Finest white	River	D
0	Blanc exceptionnel	Exceptional white	Finest white	River	E
1 +	Extra blanc +	Rare white +	Fine white	Top Wesselton	F
1	Extra blanc	Rare white	Fine white	Top Wesselton	G
2	Blanc	White	White	Wesselton	H
3	Blanc nuance	Slightly tinted white	Commercial white	Top crystal	I
4	Blanc nuance	Slightly tinted white	Top silver Cape	Crystal	J
5	Blanc legerement teint	Tinted white	Top silver Cape	Crystal	K
6	Blanc legerement teint	Tinted white	Silver Cape	Top Cape	L
7	Teinte	Tinted	Light Cape	Cape	M
8			Light Cape	Cape	N
9			Cape	Light yellow	O
10				Very light yellow	P
11				Light yellow	Q
12				Light yellow	R
13				Yellow	S
14-16			Dark Cape	Yellow	T-Y
	Couleur fantaisie	Fancy color	Fancy color	Fancy color	Z +

*H.R.D. Hoge Raad Voor Diamant (Supreme Diamond Council)

It is important to remember that colour definitions can vary from one country to another. This means that it is essential to know from which country a certificate comes. Currently, the most popular terms are those adopted in the United States (D, E, F, G etc.); they are in my opinion the clearest and most accurate. Each certificate also has a section dealing with "proportions", and it is extremely important that this section be labeled "good" or "very good". Never "poor"! For the proportions of a diamond cut have great importance for light refraction, as the drawing below will make clear.

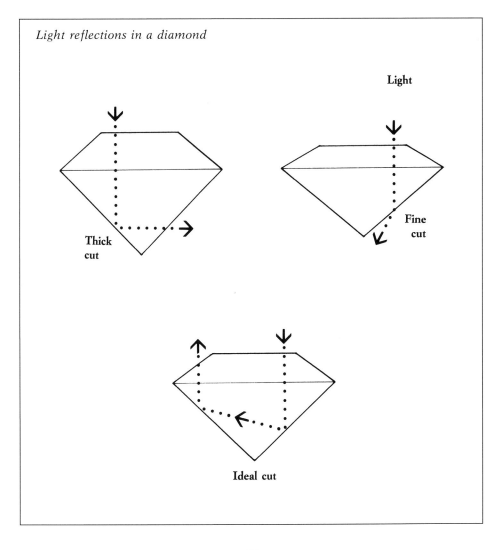

Light reflections in a diamond

Light

Thick
cut

Fine
cut

Ideal cut

Some of the world's largest diamonds

Name	Cut	Colour	Weight in carats
Cullinan I	Drop	White	530.20[1]
Cullinan II	Coussin	White	317.40
Grand Mogul	1/2 Egg	White	280.00
Jubilee	Coussin	White	243.35
Orlov	1/2 Egg	White	194.75
Regent	Coussin	White	140.50
Tiffany	Coussin	Canary Yellow	128.51[2]
Koh-I-Noor	Round/Oval	White	108.93[3]
Great Chrysanthemum	Drop	Madère	104.15
Cullinan III	Drop	White	94.40
Pelikan Doré	Emerald	Yellow	64.00
Cullinan IV	Coussin	White	63.60
Grand Condé	Drop	Pink	50.00
Hope	Oval	Blue	42.52
Dresden Green	Drop	Green	41.00
Wittelsbach	Oval	Blue	35.32
Eugènie	Drop	White	31.00
River Styx	Round	Black	28.50
Cullinan V	Triangular	White	18.80

1) *The 5 Cullinan diamonds are all cut from the same stone, the original weight of which was 3106 carats.*
2) *Originally 186.00.*
3) *Originally 287.42.*

Emeralds

Emerald is a beryl, like aquamarine. One is green, the other blue, the difference between them being of a chemical nature. Emerald is a silicate of beryllium and aluminium occurring in nature as crystals of a hexagonal pyramidal shape. The dichroism of the stone is conspicuous, varying from pale green to grass green and dark green according to the chromium content. Hardness is 7.5 on the Mohs scale, and the substance is brittle; so great care is needed during cutting and setting and in preserving the stone.

Emerald was known in ancient times. It was initially mined in the Ural Mountains, Siberia and Egypt. Following Spanish colonisation of South America, a number of old Inca mines were discovered, and these have since yielded some of the world's finest specimens. The Muzo, Cosquez, Chivor and Gachaia mines in Colombia are still worked today.

More recently, veins have been found in Brazil, South Africa, Zambia, Pakistan, Afghanistan and India, but none of these stones can equal the beauty of the Colombian specimems.

A flawless emerald is very rare. Indeed, identification of a stone is greatly facilitated by the presence of inclusions or even slight fractures. Most emeralds on the market today contain inclusions that diminish their transparency. Often the colour is irregular, the stone being darker on one side than on the other.

Emerald is without doubt the most imitated beryl. Synthetic stones are produced in Germany (Zerfass), United States (Chatham) and France (Gilson), and it would be extremely difficult for a layman to distinguish a natural from a synthetic emerald. Even expert jewellers can make mistakes, and the Chelsea colour filter which was originally designed to identify emeralds, has proved its limitations in certain dubious cases. In similar circumstamces an entire series of scientific tests is called for. In simple terms, verification of an emerald could prove a very costly operation, so I strongly advise you to seek the assistance of a reliable jeweller with a reputation to defend.

Choosing an Emerald

First and foremost, to be truly beautiful an emerald must be of a fine green colour. Green is a mixture of blue and yellow, which explains why the dichroism of emerald ranges from yellow green to bluish.

Capuano of Via Veneto, Rome. A necklace of white gold, green silk, 23 baguette-cut diamonds and an exceptional Colombian emerald weighing 33.96 carats. It was designed by Melita Capuano and is part of a special collection.

The finest emeralds come from Colombia, in particular from the Muzo mine. These are of a magnificent dark velvety green, consisting of approximately 48% blue and 52% yellow.

It is very easy to find inclusions in emeralds, and although they unquestionably undermine the brilliance of the gem, they are tolerated nonetheless, as flawless emeralds are virtually inexistent. It is to attenuate the negative effect such impurities might have on potentional buyers, that jewellers tend to refer to them as the "garden of the emerald". Having said this, you should give preference to stones with as few inclusions as possible, and in any case make absolutely sure that they do not prevent the light from being reflected by the stone.

The cut is very important, too. A stone which in its rough state is of a fine dark green can lose its original colour and seem much lighter if it is too finely cut, or if the direction of the optical axis is ignored. There are no angles to be accounted for in cutting an emerald, and the lapidary can use his own discretion to bring out all the hidden brilliance of the gem. However, it is equally true that a badly cut stone may appear to have a "gap" in the centre despite a resplendent border

Emeralds can be cut to any shape, although their system of crystallization favours the famous "emerald cut", a rectangle with bevelled corners.

Weight does not affect the price of a stone to any great extent, as it is the surface that is the guideline for evaluation. One last detail: the specific weight (or density) of emerald is considerably lower than that of the three other precious stones. It follows then that a 2 carat emerald will have a 50% larger surface area than a sapphire of the same weight, cut to the same proportions. The specific weight of emerald is, in fact, around 2.7 while that of sapphire is 4.

In brief, for a sound investment, select a stone of a fine green colour, velvety brilliance, weighing between 2 and 7 carats.

Mining Emeralds

Rather than a somewhat sterile account of tradional mining techniques, I thought readers would perhaps prefer to share the emotions of the visit I made in 1986 to the Muzo mine in Colombia. This article was originally written for the press.

Paris - Muzo:

It all began in the summer of 1986 on the beach at Monte Carlo, where I whiled away the hours totally absorbed by a fascinating book by Marie Thérèse Guinchard entitled La route des émeraudes *(The Emerald Route). A journalist for French television, Miss Giunchard had journeyed half way across the world and back to visit the Colombian emerald mines and on her return had written an account of her amazing adventure.*

Coming as I do from a family of jewellers and being myself an expert gemmologist, I was deeply impressed by the fact that a European woman had actually succeeded in reaching Muzo, the most important emerald mine in the world and a place so dangerous that it is generally referred to as a living hell. A place where death by violence is so commonplace that it arouses neither interest nor emotion.

With each page I read I became more and more determined to relive the writer's experience, though I was fully aware of the risks involved in what was nothing more than a highly risky gamble. Indeed, of the few who have been foolhardy enough to venture there, those who returned can be counted on the fingers of one hand. But I was not to be deterred.

After a twenty-hour flight from Paris, my plane landed at Bogotà at dawn. My only contact in Colombia was in Cali, the country's second largest city; so I stopped in the capital only for as long as it takes to step off one plane onto another. As soon as I arrived I phoned Paul Ziablof, not a personal acquaintance of mine, but a long-standing family friend. Ziablof listened politely as I expounded my ambitious project. He did not once interrupt me and wore an expression throughout that I can only describe as inscrutable. His answer was an ominous silence that seemed to go on forever. Up until my arrival there had been no such word as "impossible" for Paul Ziablof, but I am certain that for those few tense moments even he doubted that my plan could be accomplished. It was sheer madness to go to Muzo, a sinister location where blood is shed as freely as the rain falls. But luckily for me, Ziablof was not a man to baulk at the thought of danger. His mind works like a computer and at much the same speed. Striking the desk with his fist, he sententiously pronounced his verdict: "Claude, you shall go to Muzo, I promise you".I cannot describe my feelings as he said this. A mixture of joy, fear, pleasure, anxiety and uncertainty, I think, for I realized that those words, coming from a man like Ziablof, were the culmination of a well-conceived, well-deliberated plan that he already had in mind.

Paul instructed me to leave the very next day for Bogotà, where I was to contact a man named Juan Beetar who, together with Victor Carranza and Gilberto Molina, is indisputably one of the three emerald kings. Thanks to a vast network of contacts, in less than twenty-four hours Paul had moved heaven and earth for me, and I strongly suspect that had it been necessary he could have summoned the help of the President of the Republic himself. Paul had accepted the wager and won. He had succeeded in persuading the concessionaires to sanction my visit. That left just a few technical details to be cleared up.

On my arrival at Bogotà, I called don Juan. He was already acquainted with the situation so no explanations were needed. The following day Simon Beetar, don Juan's son, came to fetch me at the hotel and accompanied me to the Guayamarel private airport, where everyone had been informed of my expedition. Journalists and paparazzi are viewed with suspicion by the emerald prospectors who have, on many occasions and often unjustifiably, been the victims of defamatory publicity.Consequently, I was thoroughly searched from top to toe before we were allowed to take off.

The sky was clear as we took off, but as we drew near to the district of Boyaca visibility began to diminish as the mists thickened around us. We were but a few kilometers from Muzo when the control tower peremptorily ordered us back to base. I could have screamed with rage and frustration, so near and yet so far, and all because of the weather! It was maddening.

That evening, depressed and disheartened, I was back in my hotel room. Suddenly, the telephone rang. A voice informed me that I would be picked up the following morning for a second attempt. In the meantime, I learned from the hotel porter that during my absence the police had been making inquiries about my business in Colombia. Just before midnight I received a second telephone call telling me that take-off was scheduled for 8am and that I was to make my own way to the airport. I awoke at dawn to find that a note had been pushed under my door during the night. It simply said that the whole thing had been called off and that I was to make my way to an address in town. Nothing more.

Shortly after, my taxi drew up in front of don Juan's sumptuous, and heavily guarded villa. I was greeted by Simon, who placed at my immediate disposal a Range Rover and chauffeur instructed to drive me to Guaymaral.

The weather had actually deteriorated over the last twenty-four

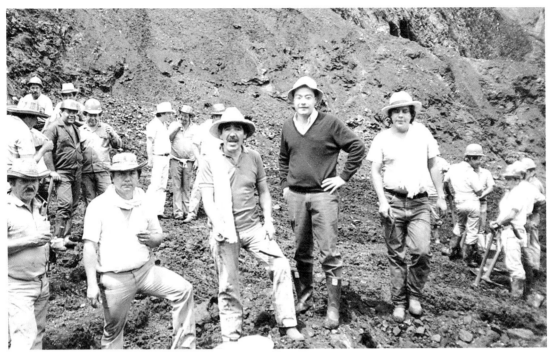

The photo taken by Captain Bustos during my trip in 1986. In the centre is Don Victor Carranza (with moustache), to his left the author.

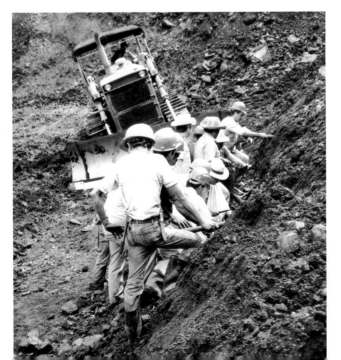

On 27 February 1989, seventeen of these miners were assassinated together with emerald king Gilberto Molina.

Calmly seated beside Don Victor Carranza at the Muzo mine, it never occurred to me that this could have been my last meal!

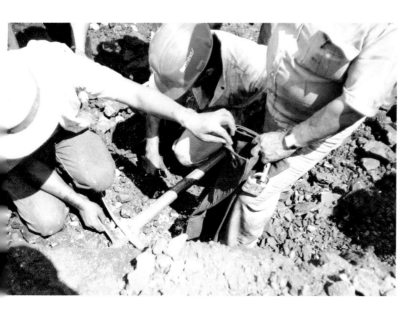

Only the padlock gives a hint that this otherwise insignificant little bag actually contains rough emeralds worth a fortune.

hours, but the new captain was a true "cascador" chosen especially for the occasion, and the helicopter was twice as big as the first. We soon found ourselves in the middle of a gale and torrential rain. Chopper champion Angel Salqado Bustos had to literally climb out of the clouds to avoid collision with a mountain, plunging down again through the mist almost to the ground as soon as he was over the top. I have never been so terrified in all my life!

The control tower, with which we had temporarily lost contact, suddenly ordered us to land anywhere we could, but the jungle was so thick that we could find no suitable clearing. We were next advised to turn back, but our captain, who was either reckless to the point of insanity or too courageous for his, and our, own good, merely winked at me and informed the control tower that he was in the middle of mist and clouds and had no choice but to go on.

A few kilometers further, beyond the next mountain, and paradise opened up before my eyes. Under a clear blue sky stretched a fairytale land as far as I could see. Bustos gave me the victory sign and pointed to a black spot in the middle of the verdant undergrowth: Muzo.

I could hardly believe what I saw. After a two hour flight, which should have taken thirty minutes, here at last was our destination. And what a destination! Paradise on earth......

Armed men guarded the landing strip situated on top of a hill overlooking the mine. From the momemt I set foot on the ground until I had opened my travelling bag I had a machine gun aimed straight at me. I was not carrying much; nonetheless, security measures had to be followed rigorously, for even the slightest oversight could have caused a bloodbath. Not only was I searched, I was also subjected to a painstaking interrogation, after which my hosts seemed at last convinced that I was really quite harmless. I was handed a pair of rubber boots and Captain Bustos conducted me to the mine where I was introduced to don Victor Carranza and his work team. Millionaire and miner, don Carranza is an amazing man, one of the only three men authorized to operate the Colombian emerald mines. I was proud and thrilled to shake his hand. A hand blackened by years of handling oxides and one that alone had extracted a third of the Colombian emeralds now distributed the world over.

Don Victor spoke only Spanish, but we managed to understand each other by using sign language. Mind you, nobody speaks at Muzo. People communicate with their eyes or with the movement of a single hand, the other being permanently attached to the essential tool of the trade, a pickaxe. Don Victor gestured to the driver of the bulldozer

to open up a passage in the rock so that I could see how mining operations were carried out. The scene that appeared before me took my breath away; white veins adorned with green crystals, the famous "drops of oil", which don Victor proceeded to gather up as though he were harvesting apples. He packed them into a large leather bag closed with a padlock which was allowed into the hands of only his most trusted aides.

It was very hot, and the blackness of the surrounding terrain contrasted vividly with the clear blue of the sky. The nearby hill had been sculptured into shape first by the "dynamiteros", then by the bulldozers, and all the ravines in the immediate vicinity had been filled with the earth that had already been removed and verified. At each new phase of the operation don Victor stopped work so that I could take photographs. At a certain point he bent to pick up a crystal from the matrix and handed it to me pronouncing his only word of the day: "Souvenir". I was dumbfounded. Where then was the violence so vehemently described by the few visitors to this hell, which I must admit seemed more and more like paradise with each moment that passed?

"Violence? Just over there, at the foot of the hill", explained Captain Bustos, pointing to some little coloured specks that could be distinguished against the black backdrop: "guaqueros". According to Marie Thérèse Guinchard, who was allowed to approach the "guaqueros", these are men who would not think twice about killing their own mothers for the sake of an emerald, and not of course for its beauty but for its worth. On average, there are five killings a day in the region. Miss Guinchard actually witnessed the execution of a worker who had stolen a gem, and she was again present when a young girl named Yanara was murdered.

The guaqueros (literally "grave-robbers") are allowed the "privilege" of panning the black mud removed from the "official" mine. There are some 20,000 of these men keeping their vigil around the mine, while no more than thirty actually work within the enclosure under the orders of one of the three concessionaires. The guaqueros are heavily armed and constantly on the alert for bandits who would kill without compunction to lay hold of the day's spoils. Sometimes these amount to as much as 10,000 carats, worth hundreds of thousands of dollars.

On the dot of mid-day, don Carranza invited me to lunch in a make-shift dining room close by the mine: four iron stakes driven into the ground supporting a few sheets of metal to protect us from the

*A lucky strike.
A blow with the
pickaxe in just
the right place
could have
surprising
consequences!*

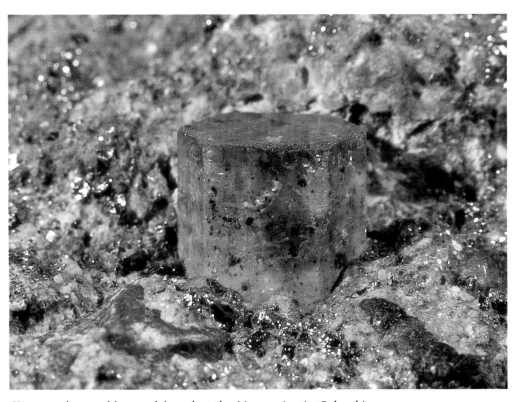

Hexagonal emerald crystal found at the Muzo mine in Colombia.

sun, a box of dynamite for a table, one glass shared by everybody and two forks, one for don Victor and the other for me. The food was simple and, under the circumstances, quite good. No one spoke or smoked, and there was no coffee, which struck me as most odd, considering where we were.

Our thirty minute break over, the powerful bulldozer once again began to dig, inch after inch, for the rest of the afternoon. I was beginning at last to relax after my adventurous morning, when one of don Carranza's aides approached me and took from his mouth a magnificent green crystal. "Que piensas?" (What do you think of it) was his straightforward question. I can honestly say that in my entire career I had never seen such an exquisitely green, exquisitely pure emerald. Only one gem in some 20,000 reaches such perfection. The man held out his pickaxe and launched a challenge: "Muzo te da lo que buscas" (Muzo will give you whatever you find), which in simple terms meant that I could keep any gems I was lucky enough to unearth. Bustos nodded his agreement. He himself was black with digging. Unwittingly I had just caught a disease that only exists in Muzo. A sort of hallucination similar to a mirage in the desert. Your eyes are inexorably drawn to the ground in search of little green stones. In fact, you see nothing but green. It is like being in a state of hypnosis. Black stones became emeralds, and I was convinced I was walking all over them. I was a victim of "green fever", which leads to senseless killing, violence and death at Muzo.

Epilogue

On 27 February, 1989, television networks world-wide announced the assassination of one of the "emerald kings". Don Gilberto Molina had been brutally murdered together with seventeen of his aides and bodyguards. Less than two months later, on 10 April, 1989, the Colombian Army discovered, at don Victor Carranza's ranch, a mass grave containing eighty bodies heaped one on top of the other. Most of them were riddled with bullets and showed clear evidence of torture. (From a report by Jean Bertolino published in the Journal du Dimanche *16 April, 1989).*

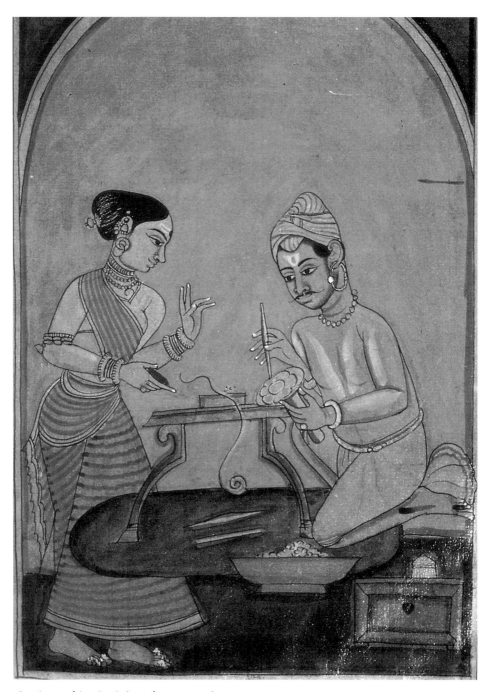

Setting rubies in Asia a few centuries ago.

Rubies

Surprising as it may seem, ruby and sapphire, so different in colour, actually belong to the same mineral family: corundum, the mineral form of alumina which crystallizes in the hexagonal system. The red colour of ruby results from a small admixture of chromic oxide. The most prized tint is blood red or crimson known in the trade as "pigeon's blood" red. The colour of this corundum varies, however, according to the geographical locality of the mine. Siamese rubies, for instance, are of a deeper garnet red than those found at Mogok in Burma, while Ceylon ruby is of a pinkish dull red. Corundum is extremely hard, 9 on the Mohs scale. It is, therefore, not quite as hard as diamond but much harder than other minerals, including emerald. Transparent ruby, when cut en cabochon, may reflect light so as to produce star-like bands, a phenomenon rated highly by the experts. If viewed from a certain direction, bands of light are reflected onto the surface of the crystal forming a six-ray star shape. This optical effect is due to the presence of fine canaliculi or inclusions of rutile. The colour of these "starstones" varies from pale rose red, to deep crimson, to purple. Generally speaking, the darker the crystal, the less evident is the star, and vice versa. It is a rare gem indeed in which the colour and the star are of equal beauty.

Choosing a Ruby

The most important criterion for evaluation of a ruby is unquestionably colour, and a number of specific terms have been adopted to describe this: first blood, pigeon's blood and ox blood. The finest gems are those of a blood red tint, though ruby sometimes contains shades of yellow and blue.

The finest rubies come from Mogok in Burma and are of a very slightly pinkish hue. In all events, the colour of a ruby must be bright, limpid and equally distributed throughout the gem, neither too dark, as this would prevent the light from penetrating, nor too pale like the colour of red tourmaline (rubellite).

Pure rubies are very rare, and the larger the gemstone, the less likely it is to be so. The presence of clouds or "silks" does not undermine the value of the gem, provided they occur parallel to the table (the flat facet on the top).

Avoid stones that are too thickly cut as these would be difficult to set, or too finely cut as this diminishes the gem's brilliance. The

ideal proportions for a ruby are: one third the crown and two thirds the pavilion. It might be that the latter is slightly off-centre, but this will not effect the value of the stone. The fault should not, however, be visible from the table.

Weight is of little consequence, but to make a good investment I would advise you to buy a stone within the 1 to 4 carat range if possible.

Sapphires

As I mentioned earlier, sapphire is corundum, too, and its physical and chemical properties are virtually identical to those of ruby. In a natural state the gem crystallizes in the hexagonal system with two pyramidal faces. It is fractionally harder than ruby. Curiously, all corundums that are not rubies are classed as sapphires, which means that this particular gem exists in many colours, from blue to green, pink to mauve, white, grey, violet, yellow and orange.

The blue colour of sapphire is due to small amounts of titanium oxides and iron. The finest colour is found in the Kashmir

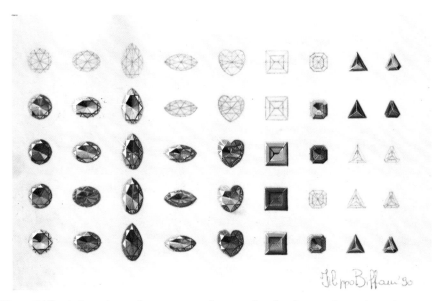

Filippo Biffani. A study on the most popular cuts for the three coloured precious stones.

For special occasions only! A diamond and cabochon-cut sapphire parure designed by Federico Buccellati, worthy heir of Mario Buccellati who was once given the title of "Mastro Paragon Coppella" by Gabriele D'Annunzio.

specimens. Ceylon sapphires are generally of a vivid blue, sometimes only partially coloured. Those found in the United States (Montana) have a bright metallic sheen, while Australian sapphires are of a deep blue-green, almost black even. These are the least valuable but most widespread, being mined in great quantity. The coloured sapphires popular today come mainly from the mines in Thailand, Ceylon and Australia. Multi-coloured specimens are also known to exist.

Transparent sapphire, too, cut en cabochon, reflects the light to produce star-like bands. These starstones range in colour from black (blackstone sapphire) to blue (*saphir étoilé*). There is also a variety known as alexandrite which is blue in daylight and red-violet in artificial light.

Both sapphires and rubies have been successfully and widely produced synthetically by the chemist, and in appearance, chemical composition and hardness are almost identical to the natural gems. Manufactured gems can generally be detected by the presence of minute black-rimmed, bright-centred air bubbles or curved bands, visible with the aid of a 10x magnifier.

The focus of the synthetic corundum production is in France, and South East Asian countries are among the biggest buyers. So beware of buying stones from foreigners or well-meaning friends who have just returned from an oriental holiday with the "bargain of the year"! Your best course of action is to consult a professional jeweller of sound reputation. In all events, seek expert advice.

Choosing a Sapphire

As with ruby and emerald, the primary standard for judging a sapphire is colour. As I said, the mineral is remarkably dichroic, but the most favoured colours are Kashmir blue and yellow-orange, the so-called "padparadscham" specimens, or yellow sapphire.

The blue variety should be free of any trace of green, the most beautiful sapphires being of either a deep, velvety ultramarine or cornflower blue. Yellow sapphire should be as close as possible to the colour of pure gold, or at most a shade darker.

Sapphire may be the most common of the four precious stones, but a flawless, finely coloured, perfectly cut specimen is a very sound investment. Sapphire is still somewhat underrated today in comparison with its three companions, mainly because in artificial light it tends to become a rather lifeless gem and may assume a pur-

ple hue. But there are a few exceptions which, on the contrary, become even brighter in artificial light.

My advice is, by all means invest in a sapphire, but make sure that the gem is perfect from all points of view and weighs between 2 and 15 carats (blue sapphire) or not less than 7 carats (yellow sapphire).

Ruby and Sapphire Mining in Thailand

I have discovered that the Thai mines are no longer as prolific as they were in the past. Albeit, the quality and beauty of the gems found in this area are still superior to most.

The largest quantities come from the Chanthaburi and Kanchanaburi regions. The former is located south-east of Bangkok, a few kilometers from the Cambodian border, the latter close to the lower tip of Burma.

There are no specific structures, either public or private, to regulate this activity. Anyone owning a piece of land can dig as many holes as he likes for whatever purpose. Most peasants use their own back gardens, and a simple hand-dug shaft may well yield a small fortune.

I was lucky enough to make the acquaintance of the richest and most powerful gem dealer in Bangkok. The story of his rise to fame and fortune is a classical example. He was born in Chanthaburi, the son of a poor peasant. Digging in the garden one day, he unearthed an enormous sapphire. It was the first of many that were to be his passport to a fabulous world of wealth and prestige. In fact, he soon became the richest man in Thailand.

There are two types of mine in use today. The more widespread is a simple vertical shaft, the other a horizontal shaft. The first can be dug in any part of the jungle and consists of a hole extending down as far as the crystalline subsoil in which the precious minerals are found. Generally, the miner gathers only the larger crystals, those visible by candlelight, this being the only source of light available.

While one man using a hand-operated bamboo elevator carries earth to the surface, a second, standing waist deep in a pool of muddy water, washes and sifts the quarried material in daylight.

The horizontal shaft is less common because it is only used in areas where faults, landslides and earthquakes occur. The miners dig into the sides of the escarpment directly into the crystalline layer, instead of digging downwards through the sedimentary soil. If they

The entrance to the mine; the bamboo hoist; inside the horizontal gallery. This rudimentary, time-honoured structure is all it takes to extract from beneath the earth one of the world's most precious minerals. A candle is the only source of light available.

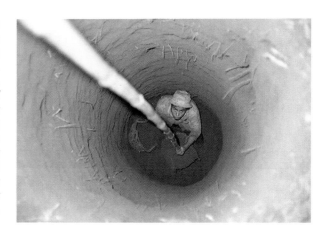

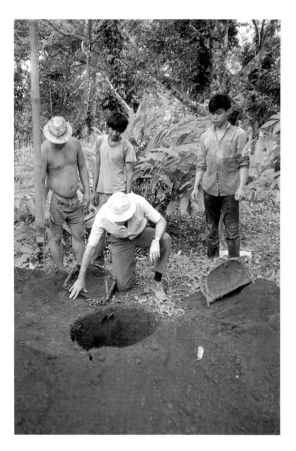

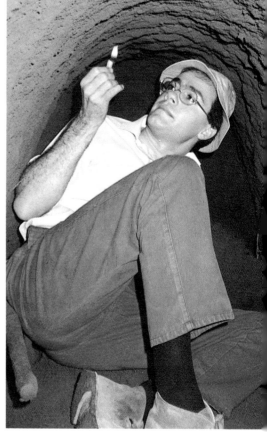

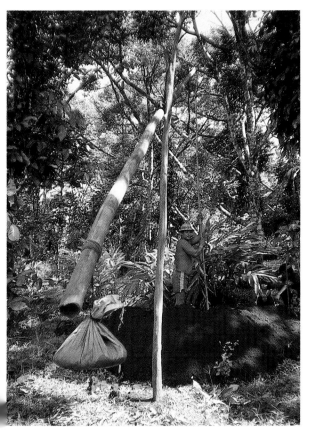

*Hoisting up bags
of crystalline earth.*

*Washing the stones in which the
precious mineral is found.*

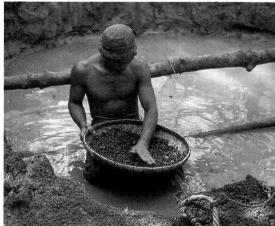

strike what promises to be a particularly rich vein, they then open a trench thus creating an artificial escarpment. Blocks of earth containing the mineral are loaded onto a lorry and taken to a nearby installation for examination. Here, an archaic looking machine operates a kind of gun that fires a jet of water onto the blocks dissolving the earth but leaving behind the stones. These are then placed onto a conveyor belt leading to two vibrators which separate the gems from the rest of the material.

The gems are sold on the spot to dealers, who are regular visitors to the mine. Some prospectors have built their own workshops where they cut the gems themselves, before selling them wholesale on the Bangkok market.

Foreign tourists can easily reach the ruby and sapphire mines of the Kingdom of Thailand, the modern name of the legendary Siam,

provided they are accompanied by a guide or a local inhabitant. The Thai people are extremely hospitable and are only too happy to have western visitors watching them at work. It is not even unusual for them to offer rough rubies or sapphires as a souvenir!

No where else in the world have I met such candid, warm-hearted people, so totally unconcerned with capitalizing on the natural wealth of their land for personal gain.

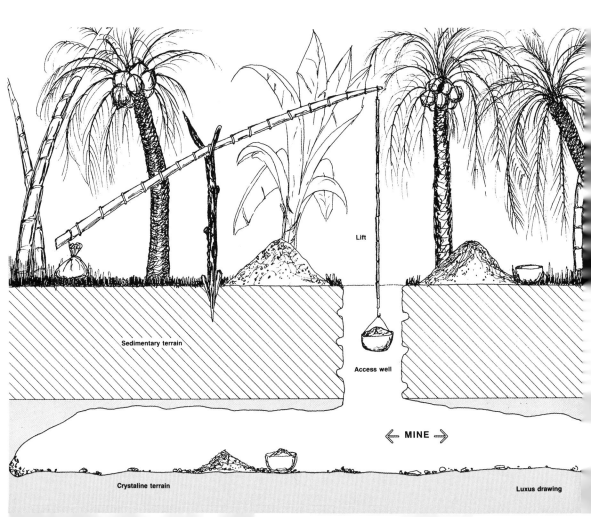

Lift

Sedimentary terrain

Access well

⇐ MINE ⇒

Crystaline terrain

Luxus drawing

The four precious stones can easily be confused with many other gems. This list will help you if in doubt.

Diamond may be confused with:

- "fabulite" (strontium titanite): a synthetic stone, equally bright but far less hard.
- zirconium: a synthetic stone.
- "strass": a hard vitreous composition with a refractive film stuck onto the pavilion.
- white sapphire: white corundum.
- yttrium aluminate (YAG): a synthetic stone, less hard.
- zircon: a natural gemstone similar to diamond but less hard.

Emerald may be confused with:

- tourmaline: darker, less brilliant.
- chrysoberyl: opaque.
- Chinese jade: translucent.
- gilson, chatham: synthetic stones.
- olivine: a variety of chrysolite of a more yellow colour.

Ruby may be confused with:

- rubellite: reddish tourmaline.
- spinel: less brilliant, no dichroism.
- almandine garnet: of a violet tint.
- pyrope garnet: darker, less brilliant.
- synthetic ruby: artificial gemstone.
- red zircon: of a brick red colour.

Sapphire may be confused with:

- blue tourmaline (indicolite): lighter, less brilliant.
- aquamarine: much lighter, less brilliant.
- blue topaz: much lighter, metallic appearance.
- synthetic sapphire: artificial gemstone.
- blue zircon: reflects lights differently.

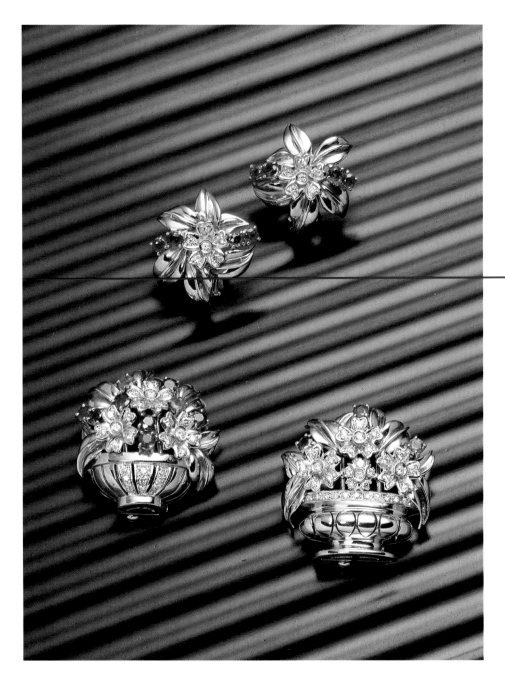

Gold brooches and earrings studded with diamonds, rubies, sapphires and emeralds. It takes the skill and experience of top designer Moraglione of Valenza to successfully blend the four precious stones in an unsuspected symmetry of colour and elegance.

Sixty Semi-Precious Gemstones

With the cooperation of Charles Mazloum - Gemmologist

The price of semi-precious gemstones varies considerably according to their provenance, current fashion and the eventual discovery of new mines or veins.

There are so many varieties of semi-precious minerals that it would take literally hundreds of pages to describe them all. So I have had to limit this chapter to a description of the most popular and easy to find. The little arrow beside the name of each indicates whether the value of the stone is currently on the rise, stable or falling.

Agate ↓

This is a semi-pellucid variety of quartz. The colours are arranged in stripes or bands or blended in clouds and classified accordingly as moss, ribbon, dendrite etc. The stone, widely distributed but not

Agate "landscape" at the Idar-Oberstein museum. The stone has not been worked in any way, but is found with this attractive banding in its natural state.

very popular, is generally brown. When used for ornamental purposes it has usually been dyed artificially as the porous nature of this mineral allows it to absorb material from solution. Brownish-orange agate is known as cornelian, the green variety chrysoprase, the blue variety chalcedony and the brownish-red variety carnelian. Black agate is onyx.

It is used for inexpensive jewellery, ornaments and even ashtrays and precision instruments.

It is found mainly in India, Brazil, Madagascar, China, Russia and Australia.

Alabaster ↓

This substance is sulphate of lime or gypsum of a white or delicately tinted colour. It is one of the softest minerals known to nature and is therefore used as an ornamental stone in sculpture, though only for internal work as it weathers easily. It is especially popular in Italy, its country of origin (Volterra, Tuscany).

It is very porous and easy to colour, but too fragile to be a worthwhile investment.

Alexandrite ↑

This is a variety of chrysoberyl, like cat's eye, distinguished by a play of colours which has earned it the name of "chameleon stone". Its natural colour ranges from dark to pale green, but in the light may appear anything from red to yellow, to orange, to mauve even, depending on how the rays strike it.

It is a very attractive stone, but rare and therefore very costly, and only the top quality is worth buying. It is, however, an excellent investment because it is much prized by jewellers and collectors.

Pure alexandrite is always faceted, or cut en cabochon if flaws are present (in this case be careful not to confuse it with other "chameleon" chrysoberyls or labradorite). Its value is on a par with the four precious stones and when well set is a match for even the finest diamond.

The best specimens come from Russia, but it is also found in Ceylon, Burma, Brazil, Madagascar and the USA.

74

Almandine →

See garnet.

Amazonstone ↓

A variety of feldspar, it is a stone the colour of which ranges from whitish green, to apple green to bluish green. It is always spangled with a myriad of tiny white striations.

It is used for inexpensive jewellery, and often as an imitation of turquoise. It has no great value being subject to damage by easy cleavage.

It is widely distributed in the USA, Canada and India.

Amber ↑

This is not strictly a gemstone but a fossilized form of resin derived from various coniferous trees. It is found in many colours and may be both translucent or opaque. The rarest specimens are those enclosing insects of extinct species and leaves trapped in the sticky exudations of the tree.

Amber occurs practically everywhere in the world, but not in large quantities. It is most abundant, however, in the Baltic regions of Northern Europe.

Unlike most other stones, its impurities actually increase its value, but be suspicious of so-called "pressed" or "compressed" amber.

It is generally cut en cabochon or left in its original shape and simply polished. Ever since ancient times, it has been used for making beads for necklaces and bracelets.

It is widely used in Muslim counties for the famous rosaries.

Amethyst →

This is a variety of quartz coloured by traces of manganese, titanium and iron. It is of a pale lilac, mauve or bluish violet colour. Very popular in the past, its current value is stable as new mines have recently been discovered. Moreover, its worth has been further undermined over recent years by the flood of tasteless objects made in Brazil.

Aquamarine, alexandrite, citrine, kunzite, morganite and topaz.

Maria-Angela Crescimbeni has ingeniously matched precious and semi-precious stones to create this attractive necklace comprising rubies, sapphires, emeralds, and a wide variety of multicoloured quartz.

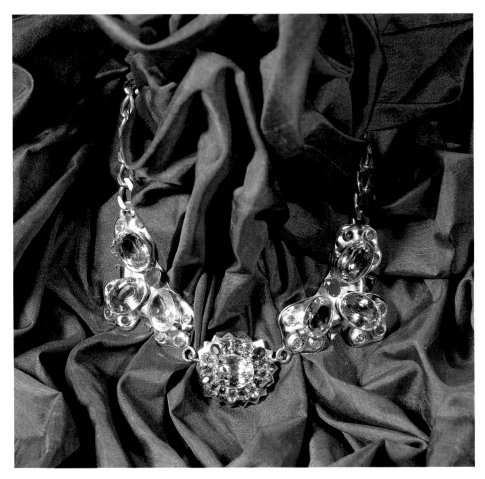

The best investment is an amethyst of average size weighing between 4 and 8 carats, as dark as possible, but not so much so that the light is prevented from reflecting, and with a deep lustre.

Amethyst has a very wide provenance, but the finest coloured specimens come from Brazil and the Urals. It is also mined in Madagascar, Ceylon, India and Australia.

Andalusite →

A hard silicate of alumina in rhombic crystals of a colour varying from pink to violet. More rarely, it may be red or green. Its main quality is its exceptional fire.

If you are thinking of buying andalusite, you should choose a specimen in its original shape, flawless and of as deep a hue as possible. The price of this stone rises steadily, but never in leaps and bounds.

It is found in Brazil, Ceylon and Madagascar and is mostly used for the creation of exclusive jewellery for a clientele of connoisseurs.

Aquamarine ↑

Being a variety of beryl it belongs to the same family as emerald. Its colour varies from an almost white pale blue to a slightly darker sky blue, this latter being the most prized of all. There are also some greenish blue specimens which potential buyers would be wise to avoid. When investing in aquamarine, choose a stone that is pure, brilliant and as dark as possible. Be careful not to confuse it with blue topaz, a far less valuable mineral.

Generally, aquamarine is faceted, except for the translucent or milky specimens which are better cut en cabochon. This cut is popular today with jewellers for the creation of reasonably-priced parures.

Aquamarine comes from Brazil, Madagascar, Russia and the USA. Specimens from China and Colombia tend to be of a yellowish tint.

Aventurine Quartz ↓

A variety of quartz spangled with inclusions giving a schiller, an unusual and attractive lustre characteristic of certain minerals. It may be green, blue, red or yellow in colour.

In the Far East it is used for elaborately decorated statuettes; in the West for small items of jewellery, necklaces and bracelets.

It is widely found in India, Russia, South Africa and China.

Care should be taken not to confuse blue aventurine with lapis lazuli and green aventurine with jade.

Beryl

See aquamarine, heliodor, morganite.

Bloodstone ↓

A totally opaque variety of quartz of a dark green colour spotted or streaked with red. It is used for small ornamental objects and for beads.

It comes from India, Brazil and Australia.

Cameo →

This is the name given to a gemstone in relief. It can best be cut on dense, hard materials that take a polish, the most suitable being the chalcedonic minerals such as quartz and agate, or shell. Less commonly, cameos are made from mother of pearl, hematite, jade, malachite and turquoise.Generally, they show portraits, scenes from classical times and coats of arms. Today, most cameos are made from shell, mother of pearl and coral. Carving or engraving on other gems is known as glyptic art.

Chalcedony ↑

A crypto-crystalline sub-species of quartz. It is generally of a milky-brown colour, but there are also rarer blue (blue chalcedony), green (chrysoprase) and orange-red (cornelian) varieties. Very occasionally it may be transparent.

Agate is frequently stained to resemble types of chalcedony; so particular care should be taken when buying chalcedony that you are not, in fact, about to be sold an imitation.

The mineral is found in Madagascar, Brazil, India, China and the USA.

*Hans Dieter Roth:
an exceptional
example of glyptic
art.*

Chrysoberyl Cat's Eye ↑

The essential quality of this mineral is a silky lustre or ray which, when the stone is held to the light, resembles the contracted pupil of a cat's eye. It is generally yellow but some specimens may be green or red.

A flawless stone may be faceted, but specimens that have optical effects must be cut en cabochon.

There is also a quartz variety known also as tiger's eye which is lighter and has a less sharp ray. It is consequently less valuable.

Chrysoberyl cat's eye comes from Ceylon, Brazil, USA and Madagascar.

Chrysoprase ↑

This is green chalcedony.

Citrine ↓

A glassy, wine-yellow variety of quartz, often mistakenly called "topaz", which is a completely different and far more valuable gemstone.

The colour of citrine varies from pale yellow to Madeira. However, the darker citrine is generally artificially formed by heating poor quality amethyst.

79

Federico Buccellati. Gold ring with a cabochon-cut "angel skin" coral surrounded by diamonds.

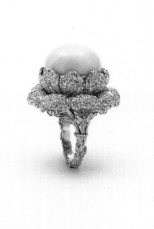

Gold bracelet studded with diamonds and decorated with an antique coral rose. The quality and size of this coral are exceptional.

The mineral is found wherever there is quartz and, in fact, it has too vast a provenance to represent a wise investment.

It is used for inexpensive jewellery.

Coral ↑

Coral is not a mineral but a hard calcareous substance consisting of the continuous skeleton secreted by many tribes of marine coelenterate polyps for their support and habitation. It is found growing plant-like on the sea-bottom. With pollution on the rise everywhere it is becoming increasingly rare, to the extent that even the most prized, the Mediterranean coral, is threatened with extinction.

Coral was very popular until a few years ago, but has now become too expensive for most pockets. Its increasing rarity does, however, make it a good long-term investment. You would be wise to buy Italian coral rather than specimens from the Far East, which have often been adulterated.

The best corals are generally considered to be those of a deep rose red colour, though some jewellers would tend to disagree. Understandably so, when it is almost impossible to find more than one or two necklaces of this shade in a hundred! As regards white and pink varieties, choose without hesitation the colour known as "angel's skin".

Weight-wise, coral is worth more on today's market than gold, which is why it is such a sound investment provided, and I stress this, it is of the best quality. The finest specimens come from Sardinia and Tunisia; larger, less fine ones from Japan and China.

Coral is cut en cabochon or used for beads and sometimes small carvings. Beware of imitations, such as coloured shell or bone.

Ebony →

A hard black or very dark brown wood obtained from various species of the Ebanaceae family of trees found in Africa, Australia and the USA. It is now used in the jewellery trade.

Epidote ↑

A mineral contained in many crystalline rocks, consisting largely of the silicate of iron and lime. It exists in a wide range of colours in-

cluding shades of green, yellow, brown, red, pink and even violet. Translucent specimens are cut en cabochon, while transparent ones are faceted. It makes highly attractive, multi-coloured jewellery.

It comes mainly from Madagascar and the USA, but can also be found in Italy, France, Switzerland and Australia.

Garnet →

The name given to a group of isomorphous minerals of different composition and colour.

Almandine is of a deep velvety red and the most widely used in jewellery making. In Austria and Czechoslovakia it is faceted and used for highly elaborate jewellery. In India it is cut as beads or en cabochon. The best stones are those that are not too dark.

Glossularite is generally olive green, but there are also yellow, red, brown and violet varieties. It is slightly glassy in appearance and only transparent crystals are used for jewellery.

Pyrope is similar to almandine, but is lighter in colour and brighter, even though it is translucent. It is often mistaken for ruby. Transparent specimens are faceted or cut en cabochon. It was very popular during the Victorian period.

Rhodolite is half-way between almandine and pyrope, being of a rhododendron red colour, and is the most prized of the garnets. The fire of top-quality rhodolite is indeed magnificent.

Garnet is found in Ceylon, Australia, Madagascar, India, Australia and Brazil.

Heliodor ↑

A variety of beryl, the colour of which varies from yellow to gold, but which in artificial light becomes almost green. It is, however, a very attractive gem and the darker specimens are a worthwhile investment. Be careful not to confuse it with yellow topaz and especially citrine quartz.

It is found in Ceylon, Madagascar and Brazil.

Hematite ↑

A widely-distributed iron ore occuring in crystalline, massive or granular forms. It is opaque and generally dark grey (almost black)

in colour. It is cut en cabochon or as beads, though in Germany it is also used for intaglios. It is similar to steel in appearance, but much darker.

Set with gold, it makes a very attractive colour contrast. It may be confused with black pearl, for which it is sometimes used as an imitation, but which has a less metallic sheen.

It is found in Italy, Germany, France, England, Switzerland and Madagascar.

Indicolite ↑

A blue-coloured variety of tourmaline. The finest specimens are of a blue ranging from aquamarine to sapphire. It has a metallic sheen and to represent a good investment should be flawless, well-cut and weigh over 6 carats.

It is found wherever there is tourmaline, in particular in Brazil.

Ivory ↓

This is a hard, white, elastic, fine-grained substance obtained from the tusks of the elephant, walrus, sperm whale and hippopotamus, this last variety being the best.

The colour of ivory ranges from white to yellowish white, to brownish white, the commonest shade being pale cream.

Ivory can be distinguished from bone by virtue of the fine tubules running through it with a spiral course which indicate the growth of the tooth. These are not present in bone.

Ivory comes from Africa and Asia.

Jade →

The definition "jade" is used to define two minerals of similar appearance but different chemical composition: nephrite, a calcium-magnesium silicate, and jadeite, a silicate of sodium and aluminium.

Both minerals are found in a wide range of shades of green, brown, yellow, grey and pink and may be either translucent or opaque. They may be milky or cloudy in appearance and sometimes speckled with tiny black spots.

The most prized of the jades, the so-called "Chinese jade"

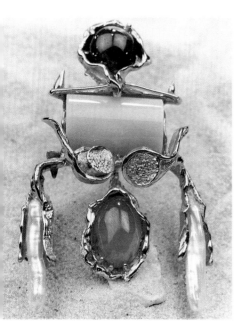
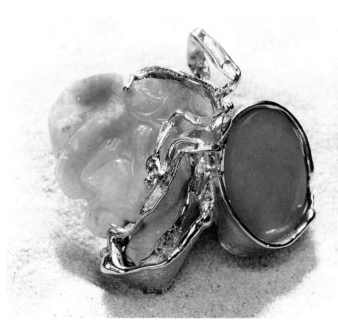
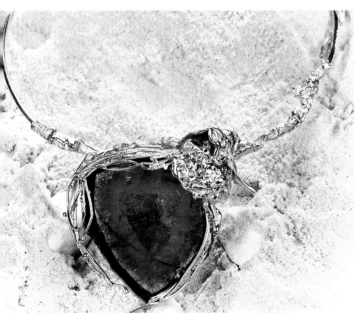
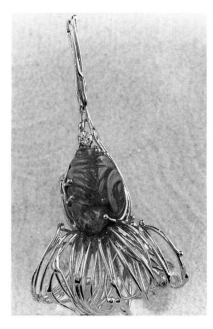

Multi-coloured tourmaline, grossulaire, rhodolite, coral, pearls and blue agate have fired the imagination of Simone Muylaert-Hofman, who has cleverly enhanced their natural beauty with gold and diamonds to create some truly original works.

(jadeite) is emerald green and so beautiful and rare that it has become exorbitantly expensive. In fact, jade is a good investment only if purchased at a reasonable price. A sound policy is never pay more for Chinese jade than you would for an emerald.

Jasper ↓

An opaque crypto-crystalline variety of quartz of varying colours, usually red, green, yellow, brown or white. It is of little value and used mostly for inexpensive jewellery and small ornamental objects such as ashtrays and candlesticks.

It is found everywhere, especially in clay.

Kunzite ↑

A variety of crystalline spodumene (a silicate of aluminium and lithium) generally of a lilac-pink hue, though yellow and green varieties are not uncommon.

If exposed to the sun, kunzite first loses its colour, then turns green and in time resumes its original hue. If you plan to buy kunzite, choose a specimen of a certain size and thickness, as small specimens tend to be colourless. It must be cut in a special way and only in facets. It may be confused with morganite and pink tourmaline (rubellite).

Kunzite comes from Brazil, Madagascar, and Burma and takes its name from the well-known gemmologist G.F. Kunz.

Lapis Lazuli ↑

The "sapphire" of classical times, it has always been a popular stone on account of its fine blue colour. It is really a rock consisting of varying quantities of a blue mineral hauyne and calcite. Small specks and strings of the yellow iron pyrites are common.

The stone is becoming increasingly rare and its price rises steadily. It now costs more than gold and is the only opaque stone, apart from turquoise, sold by the carat (provided the quality is good). My personal advice is to choose a Saxe blue stone, of a bright compact texture, with no visible specks of white or green. To the contrary, golden threads in no way diminish the value of the stone and in fact are the means by which it may be identified. Lapis lazuli may be con-

fused with sodalite, which has no golden threads, or blue aventurine, which has a schiller.

The stone is either cut as beads for necklaces or en cabochon for exclusive jewellery. It is especially attractive when set with diamonds or pearls.

The finest quality comes from Afghanistan, the lightest coloured from Chile, and other varieties from Russia and China. Widely popular in ancient times, the stone was sometimes used for decorating temples, but when the Romans realized that supplies were running low, they simply took to painting Carrara marble to resemble lapis lazuli.

Malachite ↓

This is hydrous carbonate of copper occurring in nature as an opaque stone, varying in colour from very light to very dark green. It has characteristic banding and is fragile and easily scratched.

Like ivory, this mineral has been over exploited by African craftsmen for a limitless production of tasteless, poor quality objects such as book-ends and paper weights. In ancient times it was widely used for jewellery and other ornaments because it was easy to work with and susceptible of a high polish.

It is found in the vicinity of copper mines and comes mainly from Africa and Russia, and to a lesser extent Australia and South America.

Moonstone ↑

A translucent variety of feldspar with a chatoyant quality, that is to say, having a changeable, undulating pearly lustre. It is either colourless or bluish-white and when cut en cabochon shows bluish gleams

Moonstone is not excessively expensive and being moderately rare is a good investment. The finest stones are those of a slightly bluish tint, reminiscent of the colour of the moon, hence the name.

It comes mainly from Burma, Ceylon, Madagascar, Brazil and to a lesser extent Norway and Switzerland.

Morganite ↑

This is the pink variety of beryl, ranging in colour from pale pink, to salmon pink, to crimson. It is highly resistent and has exceptional

fire. Unfortunately, it is very rare, especially flawless specimens. It is most effective when faceted, less so when cut en cabochon. If you are thinking of investing in morganite, my advice is to choose a dark, bright stone weighing from 2 to 5 carats.

It is found in Madagascar and the USA.

Mother of Pearl ↓

The name is aptly given to the lustrous pearly lining of the shells of pearl-bearing molluscs.

When polished it is similar in appearance to pearl and is extensively used for cutlery handles, buttons, buckles and other small ornamental objects. It has always been a favourite for the creation of ornaments, especially of a religious nature such as crucifixes and statuettes.

In the East it is used as an inlay for the walls and furniture of mosques.

Nephrite →

See jade.

Obsidian →

A dark-coloured, vitreous lava or volcanic rock of varying composition, resembling common bottle-glass. It is generally black but may also be brown, red or green. If cut en cabochon it has a glassy brightness.

The finest specimens come from Russia and Mexico.

Olivine →

A mineral of the silicate group rich in iron and magnesium, the gem variety of which is known as peridot. It is a relatively fragile stone of an olive green or yellow colour, the former sometimes being sold for emerald. If you are thinking of buying olivine, make sure to choose a flawless, olive green stone of compact texture, the yellow specimens being less valuable.

It is found in Burma, Ceylon, Australia, Brazil, Congo and South Africa.

Onyx ↓

This name is often erroneously applied to the alabaster, calcite and aragonite used in the manufacture of souvenirs and other ornamental objects sold throughout the tourist centres of the Mediterranean. True onyx is simply a black and white banded variety of quartz allied to agate. These bands being straight and parallel, onyx is sometimes known as "zebra agate" or, if the stone is completely black, "black agate". During the 1950s it was very popular as a stone for men's signet rings. It is now used for intaglios and cameos, necklaces and small pieces of jewellery.

It has a very wide provenance, being found wherever there is quartz.

Opal ↑

Opal, an amorphous form of hydrous silica, was once held to be unlucky, but maybe this was only because the stone is rather fragile and tends to chip and scratch easily. As it contains a high percentage of water, opal may deteriorate in heat and cold. Nonetheless, it is a very beautiful stone and, without wishing to contradict myself, it is even used as a lucky charm in certain countries.

There are numerous varieties of opal, each attractive in its own way. The harlequin opal, as the name suggests, gives a rich play of prismatic colours flashing from minute fissures, even when cut en cabochon. It is translucent and spangled with many shades of red, blue and yellow specks.

Common opal is a dull white or milky blue colour and produces the same effects but to a lesser extent due to its opacity.

Fire opal is hyacinth-red to honey-yellow and shows intense orange and red fire-like reflections. It is the only variety that can be faceted, as some specimens are totally transparent.

Water opal is similar to fire opal, but is colourless.

Wood opal is due to the replacement of fossil wood by hydrous silica with perfect retention of the woody structure. It is cut with its matrix remaining for added strength.

Precious opal, if held to the light, shows a marvellous display of brilliant colours. It is the most prized of all.

Opal should be thickly cut due to its fragility, for the finer the cut, the more the stone will deteriorate in time. It is a good idea to wash opal in pure water every now and then so as to remove all

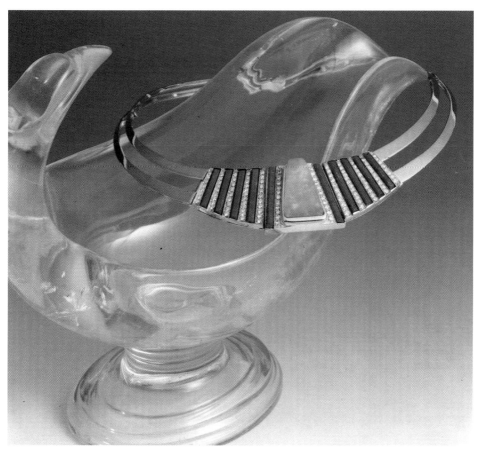

Gold choker necklace with vertical alternating bands of diamonds and lapis lazuli framing an exquisite blue opal. It is designed by Nuccia Joppolo Amato and is shown here resting on a magnificent sauce boat cut from a single piece of rock crystal.

traces of perspiration or cosmetics. In other words, opal is a good investment for the meticulous, less so for the negligent!

Even though extensive new deposits have recently been discovered in Australia, from which enough opal to virtually inundate the market could be mined, the price of this gem continues to rise.

Most opal comes from Australia, except for the fire opal which is found in Mexico.

Pearl ↑

Known as "queen of the oceans", pearl, like coral, is a victim of

pollution. The name denotes a calcareous concretion with a silvery lustre formed within the shell of certain bivalve molluscs known as pearl oysters around some foreign body. There are two types: natural pearls, formed inside wild oysters, practically impossible to find nowadays, and cultured pearls in which the production of the pearl is artificially induced. Natural pearls have no nucleus, but in the cultured variety the pearl is formed round a spherical bead inserted into the oyster shell. The oyster tries to render this intrusive body innocuous by sealing it off in a cyst of nacre.

Both natural and cultured pearls are a sound investment as their price is never likely to come down; quite the contrary, it continues to rise inexorably.

The finest natural pearls are fished almost exclusively from the Persian Gulf and the China Sea, while the best cultivated ones come from Japan, Korea and more recently Australia.

The price of a pearl depends much on its provenance, colour and iridescent lustre (known as the "orient"), perfect shape and above all size. In fact, the most important characteristic in computing the value of a round pearl is its diameter, which should exceed 8mm.

The finest colours are pinkish-white, bluish-white and white-white. Avoid pearls of a yellowish, greenish or brownish tint. Grey, blue and black pearls are to be found in certain volcanic regions such as Tahiti and may be even more expensive that the white variety.

Pearls may also be of different shapes: round, oval, button and drop (often used for earrings) or of an uneven form, which are known as "baroque" pearls.

Pearl is a rare and living substance and should be treated with great care. If you live in a hot climate, your pearls should be washed in sea water at least twice a year; in cooler climates, once is sufficient. They should not be brought into contact with perfume or other jewellery, which might scratch them.

Remember what I said about investments? Well, if you have a daughter who is coming of age, forget about the bank account, spend the money on a string of pearls. In five years time she will appreciate the difference and be eternally grateful!

Peridot →

See olivine.

Pyrope →

See garnet.

Quartz →

This widely diffused mineral includes, not only all the coloured varieties, but also agate, chalcedony jasper etc.

The colour of quartz is variable: rock quartz is transparent and colourless; citrine (the most popular) is yellow; amethyst is purple or violet; smoky quartz is yellow or brown. Two coloured varieties of this mineral are worth a special mention: blue and pink.

Blue Quartz ↑

This is the rarest quartz and is found in Madagascar alone. Being perfectly transparent it is always faceted and is, in fact, a valuable gemstone. If you should come across one, do not miss the opportunity to buy it. It is a rare and beautiful stone and a worthy addition to any collection, not to mention its value as an investment.

Rose Quartz →

This widely diffused stone is often used for statuettes, carvings and other ornamental objects in the style of Chinese art. In the West it is cut en cabochon or as beads. Unfortunately, it faces strong competition from pink beryl, morganite, topaz and tourmaline.

It is pale pink in colour and has a milky texture. Darker, transparent specimens are as rare as blue quartz.

Rose quartz comes from Madagascar, India or Brazil.

Rhodolite →

See garnet.

Rock-crystal →

This is colourless, transparent quartz of little commercial value due to its very wide provenance. It may sometimes have a smoky or even

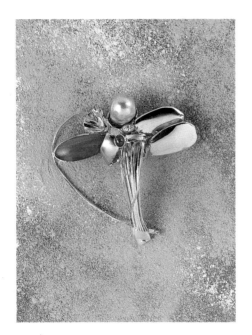

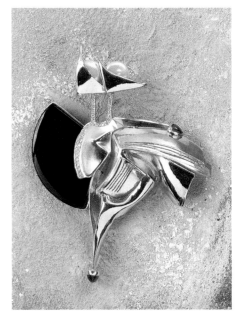

Simone Muylaert-Hofman. "I fly away" is the theme of this sculptured jewellery made of gold, different shaped diamonds, Tahiti pearls and matrix opals, rubies and pink tourmaline, pink sapphire and onyx.

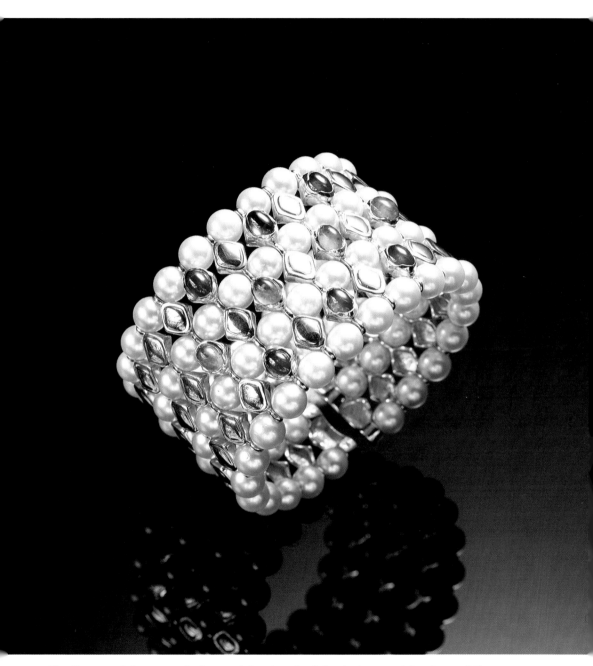

The "queen of the oceans", the pearl, has inspired the designers of the General Export Jewellery company who have created a system whereby the pearls are mounted on rigid bracelets decorated with gold and precious and semi-precious stones.

93

decidedly brown colour. The finest specimens are the slightly tinted ones pierced by coloured inclusions of rutile.

The stone has industrial applications and may be used for beads, statuettes and other small ornaments. It is found in Brazil, Madagascar and India.

Rubellite ↑

See tourmaline.

Serpentine →

Similar to jade in colour, structure and brilliance, this ornamental stone has much the same uses, too. It is very easy to work, being even softer than jade.

It is found mainly in Europe, especially France, Switzerland and Belgium.

Sodalite ↓

A mineral similar in appearance to lapis lazuli for which it may easily be mistaken. Sodalite is, however, a lighter blue and has red, orange and yellow spots, but no gold threads as it contains no iron pyrites.

It is far less valuable than lapis lazuli and is not considered a good investment, precisely because of the confusion its similarity to the rarer stone may cause.

It comes from Russia, Italy, Norway, India, Brazil and the USA.

Spinel ↑

The typical species of the spinel group of minerals occurs in many colours, though more commonly brown, red, blue and violet.

Enormous quantities of this attractively bright stone are sold as rubies and sapphires, which they do closely resemble. So beware, if a jeweller starts talking about a "spinel ruby" or "spinel sapphire", he is definitely trying to pull a fast one! Simply reply that there are no such things; a ruby is a ruby; a spinel is a spinel, and there can be no compromise between the two.

Spinel comes from Ceylon, Brazil, Madagascar and India.

Sunstone ↑

Like moonstone, this mineral is a variety of feldspar, either red, orange or yellow in colour. It is not truly iridescent, but produces a coloured schiller due to minute embedded crystals of an iron mineral.

It is always cut en cabochon and is used for selective jewellery. It is still possible to buy sunstone at a reasonable price, though in my opinion it is second to neither topaz nor the beryls.

It is found in India, Russia and Norway.

Tiger's Eye ↓

This is similar to quartz cat's eye. It has optical effects and is therefore cut en cabochon or as beads. It occurs in many different colours from dark brown to beige, from black to slate to grey. It forms bands and changes colour depending on how the light strikes it.

Being rather common it is not a very valuable stone. Moreover, it has been exploited in every way imaginable. Albeit, the optical effects it produces are far from unattractive.

It is found throughout Africa, Asia and Australia.

Topaz →

A mineral of somewhat varying composition belonging to the silicate group. It is not a quartz and therefore has nothing in common with citrine quartz, a far less valuable stone.

True topaz may be yellow, gold, pink, blue, green, mauve or red. It does not reflect the light to any great extent; so the larger the stone the better. It is widely used in jewellery making and frequently imitated by citrine quartz.

It comes from Brazil, where it is as widespread as amethyst, Australia, Madagascar, USA, Mexico and Ceylon.

Topaz Fumeé (smoky topaz) →

See quartz.

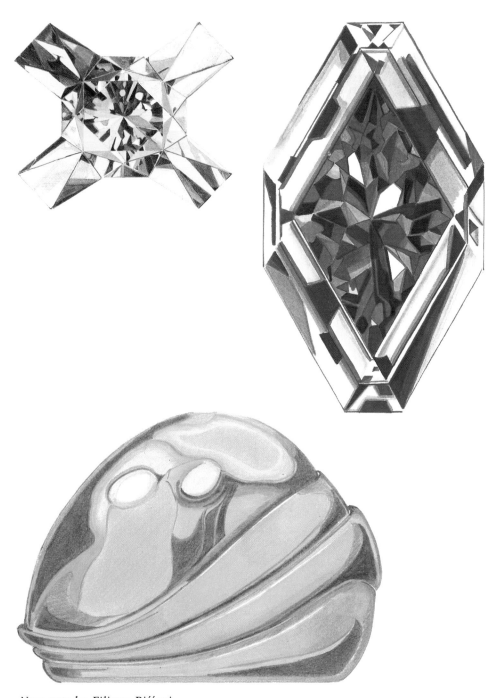

New cuts by Filippo Biffani.

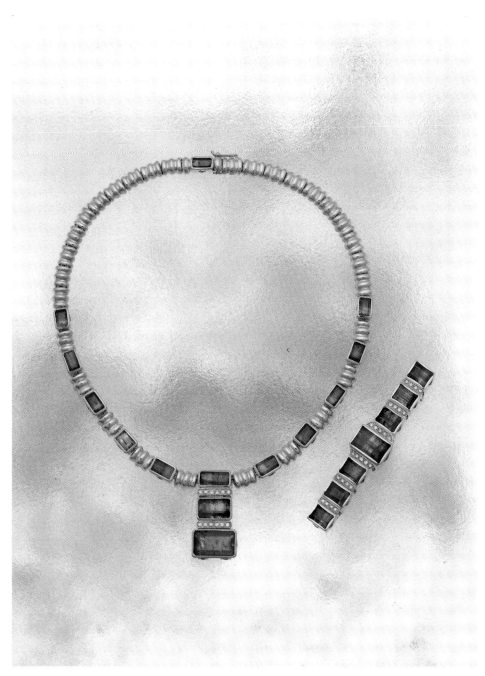

Nuccia Joppolo Amato: gold necklace and bracelet with diamonds and tourmaline.

Topaz *Goutte d'Eau* (droplet topaz) →

This is a completely colourless variety of topaz, very easy to find in the Brazilian mines and of no interest as an investment.

Topaz Quartz (burnt topaz) →

See citrine.

Tourmaline ↑

Unlike amethyst and topaz, tourmaline has escaped inordinate exploitation on the Brazilian market, probably because it is rarer and consequently more expensive. It is a mineral group of varying composition occurring in different colours, especially green, blue and grey. Pink specimens are known as rubellite.

Tourmaline has a deep brilliance and rich colouring. Transparent specimens being quite common, the stone is either cut en cabochon or faceted. Specimens with inclusions are used for beads.

Green tourmaline should not be confused with emerald, or red tourmaline with ruby.

It has a wide distribution and is especially diffuse in Brazil and Madagascar.

Turquoise ↑

This stone is becoming increasingly rare and costly because the finest material comes from Iran. Despite its fragility it is much prized and never seems to go out of fashion.

It is an opaque mineral consisting essentially of phosphates and is of a colour ranging from sky-blue to apple-green. The best turquoise is, however, dark and should be totally free of any black veins or white specks. It must be cut en cabochon. It is sold by the carat, a very rare procedure for an opaque stone.

Turquoise is an excellent investment, but if it is to retain its value it should be cleaned at least once a year with diluted ammonia liquor. This restores its original colour which otherwise tends to become greener with age. It should never be stored with other jewellery or cosmetics.

As I mentioned earlier, the finest turquoise comes from Iran, but specimens from Sinai and China are almost as beautiful. Russian and American turquoise is of a decidedly poorer quality.

Yellow Sapphire ↑

A variety of corundum, like ruby and sapphire, which could be considered a precious stone as it is, in reality, an orange sapphire. It is virtually unknown to the vast majority of people and can therefore be purchased at a reasonable price. However, jewellers are beginning to promote it more and more, and this is a sure sign that the current favourable situation will not remain stable for much longer.

It is best to choose a darker coloured stone with a brilliance similar to that of diamond.

Yellow sapphire is found wherever there is sapphire, especially Thailand.

Zircon →

A silicate of zirconium, this mineral occurs in different colours or may be colourless, the latter often being referred to as the poor man's diamond. In fact, zircon tends to be rather dim and is only used for inexpensive jewellery.

It is widely distributed throughout Ceylon, India and Madagascar, but is not a good investment as it is often adulterated and may be the cause of confusion. Moreover, it is fragile and easily turns cloudy.

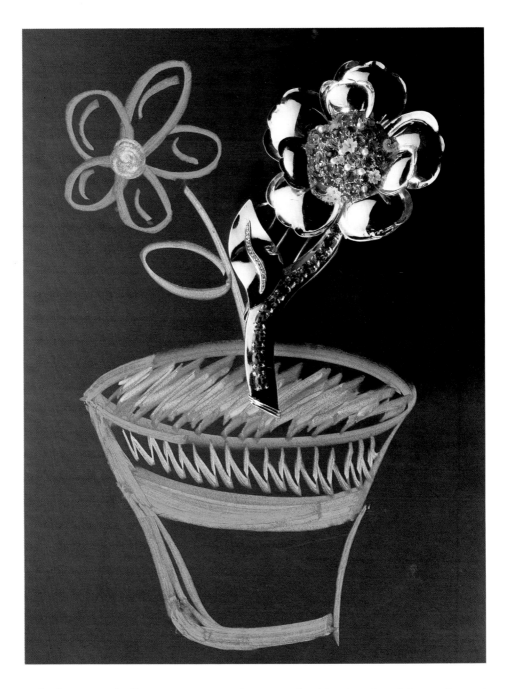

"The flowers in the flower". Maria-Angela Crescimbeni has interlaced tiny sculptured stones and mini-cabochons to fashion this delicately romantic brooch.

Part Two

Buying Jewellery

Buying jewellery is a very delicate business, yet most people attach as little importance to it as they would to buying a pair of shoes, for instance. In this chapter I will tell you where to go to buy jewellery and gems, and something about the people who sell them. I have also included some useful tips for choosing jewellery.

First of all then, where to buy.

Shopping plazas and department stores

The less said the better! Take my advice and keep well away. It is totally ignominious to debase jewellery to such an extent. Fortunately, this type of commerce is not widespread, yet.

Buying by mail order

More often than not, jewellery can be made to look more attractive in an advertisement than it is in reality. Indeed, it is incredible the lengths to which some manufacturers will go to attract prospective customers, filling their catalogues of essentially poor-quality merchandise with a string of superlatives such as "exclusive", "exceptional", "superb". However, anyone with a minimum of common sense knows the golden rule: never buy anything without having seen it first!

The little shop down the road

I am sorry to say that if you are looking for a good buy, you will rarely find it here. I tend to compare these pseudo-professionals with

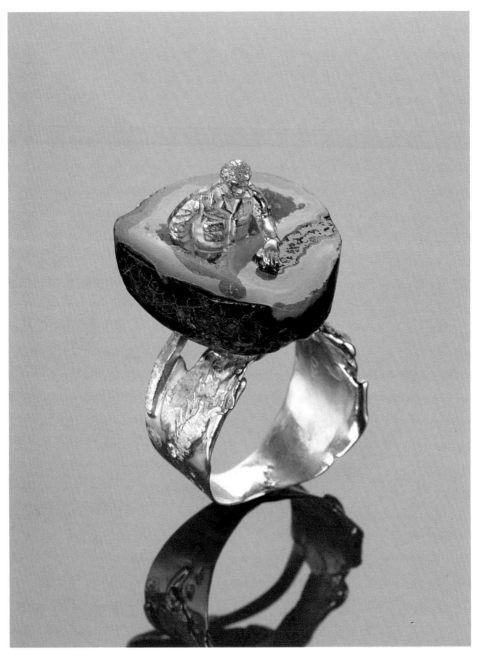

Claude Mazloum. This gold ring on which is mounted an agate geode is entitled "The man and the stone" (Idar-Oberstein Museum). It is a symbol of the relationship between the seeker of precious materials and the nature from which they originate.

petrol-pump attendants, little more than middle-men between the manufacturer and the public.

At regular intervals the representative calls in to deliver his goods, which the jeweller puts either in the display cases or the safe, to be sold as soon as possible. He rarely has the expertise, or desire, to judge design and quality. Nor is this his concern, his main interest being to make as large a profit as possible for himself. He does little to help customers in their choice, most of his stock remaining well out of sight, especially the more innovative objects which might mean less money in his own pocket. At most, these shops will provide small gold objects such as the chains and medallions often used as christening and confirmation gifts.

The high-class jewellers

By this I mean establishments of international standing, whose splendid show-rooms embellish Place Vendome in Paris, 5th Avenue in New York, via Montenapoleone in Milan, Ginza in Tokyo, rue du Rhone in Geneva, just to mention a few. Places where you can be sure to find authentic treasures of the very best jewellery. Quality is indeed impeccable, the prices outrageous!

Before you enter one of these establishments, take a good look at your latest bank statement. The larger it is, the more obliging they will be. Generally speaking, this *corps d'elite* is not comprised of what you would call the most modest of people and they do tend to have rather inflated opinions of themselves. They may in part be forgiven, for their jewellery is the work of exclusive designers and highly skilled craftsmen. Here, you are sure to find quality, even if you do pay exorbitantly for it.

Whatever you do, ask for detailed information about the piece of jewellery you are thinking of buying: its history, provenance, why it is being sold. These are determining factors and require careful evaluation. Examine the object closely, note the reaction of people around you and listen to their comments.

Before you even think of consulting the price list, decide firmly on your own limit, bearing in mind any luxury tax or other costs that will be added to the basic price. Do not allow yourself to be carried away by too vast a selection, but focus your attention on just a few well-chosen items.

Gemstones above a certain value must be accompanied by a certificate issued by the Chamber of Commerce, guaranteeing the gem's authenticity.

One last piece of advice, avoid sales organised during the months of November and December, as this is the time for selling off stock left over from the rest of the year. Moreover, Christmas is coming and the shops are not particularly inviting anyway. The summer months are more auspicious as most people are either on vacation or "broke" after one, so the shops are quieter.

The flea markets

Very much in vogue at the moment in Europe. But in order to approach one of these trading places with a view to buying, you must be both highly experienced and very astute. Without these two qualities keep well away, for the traps, whether voluntary or otherwise, are many and varied, and it is not unheard of for even the most seasoned dealer to be caught with a fake.

As a rule, the seller is content to make a small profit, but not to give it up altogether! But then this is the rule of the flea market, and everyone is expected to bargain to the best of his ability.

Do not forget to ask for an invoice or at least a receipt, if only to avoid the unpleasant consequences of having unwittingly purchased goods of dubious provenance.

Pay only by non-negotiable cheque and remember that second-hand jewellery is exempt from luxury tax, this having being paid by the original buyer.

Art galleries

Sometimes in such places it is possible to come across sculptured jewellery. Generally, this is more than acceptable from an artistic point of view, but may be technically amateurish. But then we can hardly expect a painter or sculptor to turn jeweller from one day to the next. And you will find that even Braque, Picasso and Dali sought the talent of master craftsmen for the actual making of the sculptured jewellery they designed.

If you do decide to buy one of these ornaments, you must first make up your mind whether you are actually going to wear it or merely display it. Quite often, sculptured jewellery is far more striking in a display case than as a personal adornment.

In all events, ascertain if the piece of jewellery you are thinking of buying is the only one or if there are copies. Remember, "the fewer the better". Ideally, objects should be numbered and signed by the artist.

In certain European countries and in America this type of jewellery has become a popular alternative to the rather hackneyed stock of the majority of today's jewellers, who are far more absorbed by the commercial rather than artistic aspect of their trade. The general public has little or no idea of what goes on in the designer's studio. The art galleries are merely trying to bridge the gap; often they themselves are not familiar with the trade, but at least they appreciate the artist's message.

The creators of jewellery

There are many of these craftsmen in Europe, a few in the United States, but all are virtually unknown to the general public. We know of their existence by heresay alone, or through an article we may have read in some magazine.

Each creator of jewellery has his own style and work method, but rarely does he have the means to advertise. In France they are actually boycotted by the famous HBJOs; they are tollerated in Belgium and England and encouraged by jewellers in Germany, Japan, Italy, Switzerland and the USA. Anyway, it is here that you will find what you are looking for: not pret-à-porter but "made to measure", often at very reasonable prices because these craftsmen have fewer running costs to meet. A possible disadvantage is that you will probably have to wait some time, for these are true artists, who reflect at length even before they lift a finger. Given a free hand, their work is close to perfection.

The artist will probably ask for some pictures, such as those to be found in fashion magazines, to give him some idea of your taste in jewellery. If your have any gemstones or pieces of jewellery you no longer wish to kcep, these could be used as raw materials for the new creation. Take great pains to explain exactly what you want. I can assure you the result will be an exquisite, personalized jewel, and one that will be especially dear to you because it is unique.

"Made in Italy"

Wherever you are, insist on Italian-made jewellery, unquestionably the best in the world. This country has a time-honoured tradition in the design and manufacture of ornamental objects. The quality/price ratio is excellent (obviously, if you do not take into account the profit - often excessive - made by the retailer).

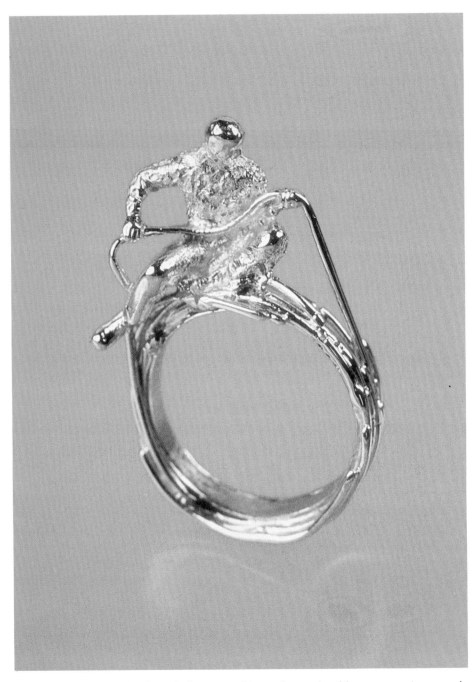

Claude Mazloum: "The thread of time". This sculptured gold ornament is part of a splendid collection that can be admired at the Wuppertal History Museum in Germany.

Some two thirds of Europe's overall production comes from Italy, the cities of Valenza-Po, Vicenza and Arezzo being the centres of the trade. There is an unjustified tendency in other European countries for jewellers to discredit Italian production, whether out of spite or simply to protect their own interests, I cannot judge. This is particularly the case in France, where they will even go out of their way to convince you that buying jewellery in Italy means falling prey to calculated deception! This is probably due to the fact that in France all jewellery must bear an official hallmark, which is not the case in Italy where responsibility is left entirely to the discretion of the maker, who applies his own, personal identification mark. Not that this really justifies the distorted attitude and misplaced criticism of the French. I can personally vouch for the integrity of Italian jewellers and craftsmen, for during the eight years I practised my profession in Paris, not once was my work officially inspected, whereas an Italian colleague of mine had two inspections in one year. So on your next trip to Italy, have no hesitations about buying Italian jewellery. It is beautifully designed, superbly made and not too expensive (in some cases a third of the price of a similar object made and sold in France).

The jewellery of South-East Asia

Over recent years, Thailand, Hong-Kong and Singapore have earned a fair reputation as an alternative market for precious objects. However, although prices are marginally lower than in Italy, there can be no comparison from either the technical or artistic points of view. Shall we say that the work is acceptable, but in no way outstanding. By all means buy gemstones in this part of the world, in Thailand especially, but have them set in Europe.

Stefano Michelangeli-Polimeni: This diamond, tiger's eye and lapis lazuli brooch is a perfect example of how the art of the jeweller can indeed emulate that of the sculptor.

"The midnight sun", a gold and diamond brooch by Stefano Michelangeli-Polimeni. Here the designer has expressed his creative genius as a painter does in his paintings. Sculptured jewellery embodies three values: art, craftsmanship and precious raw materials.

Filippo Biffani: drawing for a necklace composed entirely of varied fine stones in square and cabochon cut.

Roberto Mangiarotti: pin formed with white gold, sandy rock crystal, diamonds and an amethyst. «A beautiful object must be well-made both front and back».

In conclusion, three simple tests that you yourself can carry out to assess the finish of a piece of jewellery. Two are based on the sense of touch, which is particularly effective in judging the quality of workmanship.

The first test is designed to ascertain the strength of the jewellery. It is held between the thumb and side of the index finger and should remain totally firm to the touch when a strong, steady pressure is applied.

For the second test, rub your fingers very lightly over the entire

surface of the object. It should feel completely smooth, with no trace of unevenness or scratching. Having said this, I should add that it is normal for the claws of a collet to have a certain roughness.

The last test consists of rubbing the front part of the object over your sweater. I hardly need say that it should not pull a thread!. These simple gestures will show that you are not totally ignorant of what you are doing.

The price of gold and precious stones increases approximately 10% each year. Hence it follows that, in regard to French-made jewellery, it will take sixteen years before the value of the raw materials covers initial manufacturing costs, profit margins and tax. For Italian-made jewellery, seven to eight years.

Nonetheless, jewellery and gemstones are still an excellent investment in comparison with certain other industrial products, which never make up the initial purchase price.

The following table gives the price break-down for the same piece of jewellery in two different countries. The jewellery in question countains raw materials worth 2.000 French francs.

Jewellery made and sold in	France	Italy	South-East Asia
Cost of the raw materials used to make the piece of jewellery	2.000	2.000	2.000
Labour costs or workmanship	1.200	800	1.000
Profit margin of the manufacturer and representative	1.200		
Profit margin of the retailer	3.800	600	
Value added tax (VAT), a luxury tax	1.800	600	0
Selling price	10.000	4.000	3.000

One of the main streets of Antwerp on which is centered the diamond trade of Antwerp.

A diamond merchant examining a 4 carat stone. The pincers and magnifier are essential tools of his trade.

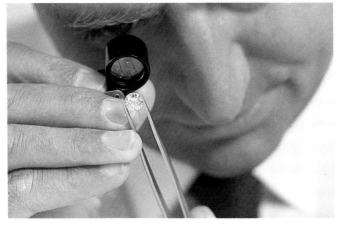

Buying Gemstones

Over the years, many cities and localities have pursued a line of production for which they have earned world-wide recognition: Murano for its glass, Limoges and Sèvres for their china are ideal examples. In the same way, certain localities have become famous for their gemstones. Everyone knows that cut diamonds can be bought in Antwerp, emeralds in Colombia, rubies and sapphires in Thailand, all varieties of rough stones at Idar-Oberstein in Germany, pearls in Japan and coral at Torre del Greco. Of course, all these stones can be bought from jewellers and dealers everywhere, but with holiday horizons reaching to the four corners of the globe, more and more people nowadays have the opportunity of buying these items on the spot, a souvenir of their visit. The following pointers are intended for these people in particular.

In writing this chapter, I was assisted by one of the world's most renowned gemstone merchants, who exercises his profession in Paris, Milan and Geneva. Together, we visited all the countries mentioned here, jotting down page upon page of information, much of which we will be passing on to our readers in this chapter. Not all the information is strictly connected with the subject, but it will serve to make your trip much more enjoyable.

The Diamonds of Antwerp

Unlike the city of Amsterdam, whose diamond trade was severely compromised by rigid tax and customs obligations during the years 1920-1930, Antwerp still benefits today from a decidedly tollerant attitude on the part of the State, well aware that if its tax inspectors

Diamonds as far as the eye can see being sorted in Antwerp.
Below: heart-shaped diamond.

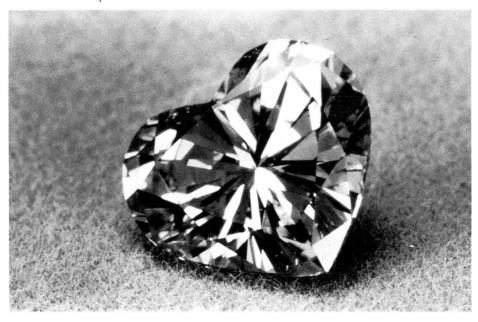

did not turn a blind eye (or two!), far from being the richest city in Belgium, Antwerp would soon become the poorest city in Europe!

Incidentally, I discovered that most people are convinced that the best diamonds do, in fact, come from Amsterdam. No longer: the centres of the diamond trade today are Antwerp, New York, Bombay and Tel Aviv.

Anyway, for the Antwerp diamond merchants the sale of one or one hundred carats is a transaction of equal importance and their reasoning cannot be faulted: today you are only buying a small diamond....tomorrow's will be bigger! You will always be welcome, though perhaps the warmth of the welcome will depend to a small degree on the reputation of the person who has sent you.

Choosing the right diamond merchant

For obvious reasons of discretion, security and fair-play, I will not be quoting any specific names. However, in general, all the diamond merchants of Antwerp are of the same professional integrity. The un-written law of the trade is inflexible: anyone committing even a minor impropriety to the detriment of a customer or colleague will be forfeiting his good name irreparably.

Thousands of transactions, worth millions of dollars, are made daily in Antwerp. Merchandise and money pass from hand to hand with no certificate or receipt given. In this city, where no one goes back on his word, a promise is a solemn vow. As I said before, the slightest professional error would cost its perpetrator his reputation.

The majority of diamond merchants (over one thousand) are to be found in the vicinity of the main station, in particular in Pelikanstraat, Schupstraat and Hoveniers-straat. In the evening the entire area is closed off by the police and no one is allowed to enter. Nearby are the stock exchange and the Supreme Diamond Council. The merchants do not conduct business from shops, but from offices located in some twenty buildings kept under 24-hour surveillance. And this is why you should never approach a diamond merchant without first having made an appointment.

Pre-purchase preparations

In order to enter the privileged world of the Antwerp diamond merchants it is essential that your attitude be reassuring for the seller.

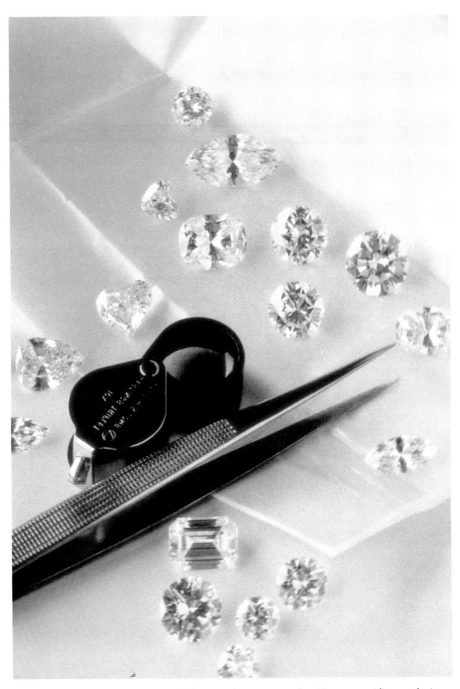

If you are going to buy a diamond this is what you need: a 10× magnifier and pincers.

Furthermore, the rules of the trade must be rigorously respected at all times. Punctuality is essential, not just out of politeness, but for security reasons, too. You must first telephone to say how many persons will be present at the appointment, and the secretary must be informed immediately of any change in plan. It is a good idea to carry with you a personal visiting card on which you should also state, if possible, the name of the person who recommended you.

Along with the visiting card, I suggest you also take with you a 10 x magnifier and special diamond tweezers. These two instruments, indispensable when buying a gemstone, are very simple to handle and the merchant will be only too pleased to show you how to use them. This will help to dispel the slight tension sometimes felt at the outset.

Buying

This is the main point of the conversation. Remember, it is always advisable to state clearly what you want to see and buy. It is pointless to negotiate the price, once this has been stated, for nowhere else would you be offered a better one. Lastly, make sure you have understood payment and delivery conditions.

Certified diamonds over a certain size all bear a number on the girdle.

Certified Diamonds

These are diamonds sealed in a plastic covering together with a microfilm of the gemstone's identification certificate which includes details of its weight, colour, clarity, cut, proportions, size, finish and fluorescence. There are several types of certificate issued by both private and public laboratories. Apart from those issued by the official chambers of commerce, equally reliable are those of the Hoge Raad Voor Diamant (HRD), in other words the Supreme Diamond Council of Antwerp, and the Gemmological Institute of America (G.I.A.).

Emeralds in Colombia

Without a shadow of doubt, concealed within the Colombian mines are the world's most magnificent emeralds. They are cut on the spot; and Bogotà, the capital, is the home of the world's largest emerald market. Both real and fake, these gems are on sale on every street corner. Tourists beware: unless you are exceedingly careful, you are likely to be literally stripped of everything you own, watch and documents included! However, if you are prepared to follow a few basic rules, you could indeed make an exceptional buy, a romantic and thrilling conclusion to an unforgettable holiday.

When to visit Colombia

Colombia has a very varying climate and virtually no seasons. Temperatures fluctuate considerably depending on altitude: being situated so close to the equator, below 1000 metres it is unbearably hot; from 1000 to 2000 metres the climate is more temperate; from 2000 to 3000 metres it is cool, up to 4000 metres cold, and above this altitude positively freezing.

Bogotà is situated at an altitude of 2600 metres and has an average annual temperature of 14°C, so all that you need is a light sweater. But when the skies clear and the sun comes out, the temperature can double in just a few minutes.

The second largest city is Cali, a very pleasant locality situated in the Cauca valley at an altitude of 1000 metres. The climate here is temperate, with tempertures in the region of 23°C all year round even when it rains.

Medellin, an industrial city, is situated at an altitude of 1500 metres. Average temperatures range from 19°C to 23°C.

Colombia's most important port is Barranquilla, where the temperature rarely drops below 28°C and often exceeds 35°C.

Cartagena, to the south, has instead a magnificent climate and is the country's most exclusive seaside resort, very popular with foreign tourists and wealthy Colombians.

Where to stay

Hotel prices in Colombia are very reasonable. Even the best 5-star hotel is cheaper than Europe's worst 3-star accommodation. However, take the advice of one who spends more of his time in hotels than at home and keep well away from the smaller hotels; it would be asking for trouble, and could even be dangerous. Moreover, and in terms of cost, you would be saving very little. The Intercontinental Hotel chain is well-known throughout South America and especially in Colombia. It is run according to the same standards provided in Europe.

The first thing to do upon arrival at the hotel is to place all your documents and valuables under lock and key, either in the safe in your room or at the reception desk. Even though you are obliged by law to carry identification with you at all times, the card issued by the hotel stating your room number will suffice. A lost identity card will most certainly be used for illicit purposes!

What to buy in Colombia

The main purpose of this book is to provide readers with sufficient practical knowledge to be able to secure the best possible bargain with the least possible risk. For in Colombia, even with only a limited understanding of the subject, it is possible to pick up emeralds and jewellery at quite reasonable prices.

In addition, labour being cheap in this country, it is not difficult to find low-priced ornamental objects in the style of pre-Colombian art, and a variety of other handicrafts.

Where not to buy

A word of warning about the street vendors seen in practically every Colombian city. They will boldly come alongside you flaunting their

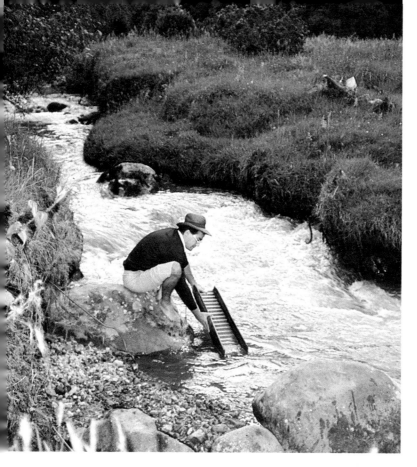

Prospecting for gold in the Choco region, using the age-old yet practical wooden "canalon". An original and sometimes lucrative hobby.

Pre-Colombian gold jewellery at the Bogotà Gold Museum, a collection unique of its kind in the world.

The small-time emerald merchants trade openly in the streets. In the midst of this motley crowd, shady dealings are carried out under the watchful eye of a cohort of "headmen". Tourists beware, this is an area to avoid.

goods: green stones, sometimes magnificent, but undoubtedly fake. Have no qualms about getting rid of these people as quickly and convincingly as possible, for they think all foreigners are stupid. At Bogotà there is a road famous for the trading of emeralds; it is known as the Calle de los Esmeralderos, but was recently renamed Calle de los Gemmistas (road of the gemmologists)! In reality, this road is part of the Avenida Jimenez de Queseda or Calle 13, situated between Carrera 7 and Carrera 8.

Every day, along the crowded pavement as far as the Banco de la Republica, millions of dollars (black market, of course) exchange hands. Unsuccessful merchants or those not tolerated on the legal market by the emerald mafia mingle with the hawkers and shoe-shiners and, when not pursuing other business, will try to approach passing tourists. Armed to the teeth, they are constantly on the alert, ready to run should the police appear. Private "barbouzes" hired by these gemmologist-merchants are there to detect the slightest suspicious move on the part of the authorities.

At my first attempt to take photographs for this book, my camera was snatched from me and unceremoniously smashed to pieces. At my second I barely escaped an ignominious beating at the hands of an angry crowd which chased me through the backstreets of this infamous area.

Not far from here is the San Victorino market, a den of iniquity in the form of drugs, weapons and explosives. Counterfeit banknotes are sold at 1/10 their value and, for ten dollars, blank, signed local and international cheques can be procured. All this is going on within the confines of innocent-looking fruit and shoe shops and sometimes in the street behind the fruit and vegetable stalls.

Of its kind it is certainly a unique area, and well worth a visit. You do not necessarily have to buy anything, but it is fascinating to see. However, avoid running unnecessary risks by asking someone who lives there to accompany you, and leave all valuables behind, watch and wedding ring included. Hide in one of your shoes the 5000 pesos necessary to hire a taxi at the first sign of trouble. One last piece of advice: it is a waste of time to visit the shops sponsored by the hotels because although you will not find fake stones there, the choice is poor and not particularly interesting. They are typical traps for the misinformed tourist.

Where to buy

I cannot stress enough the importance of going only to the best-known emerald merchants who have a sound reputation to defend.

In view of the difficulty of ascertaining the quality of a stone in Colombia, your best course of action is to seek a direct introduction to the merchant. Some of them are internationally famous and may be trusted unconditionally.

As in Antwerp, it is essential to make an appointment by letter or telefax prior to your departure. With the cooperation of the Colombian embassy in your country of residence, the Banco de la Republica will provide you with a list of some thirty export firms, which, incidentally, are also the owners of some of the most prized collections of pre-Colombian jewellery. Twelve highly reputable companies are located in Bogotà alone.

A lucrative pastime

Europeans are great hobby lovers, passing week-ends and vacations engaged in their favourite spare-time activity, whether it be fishing, mushroom picking or hunting. In Colombia the *ne plus ultra* is prospecting for gold! Not only is this highly original, it is also good fun and within everybody's reach, for no authorization or official permit is required. This is a country of infinite natural resources, and gold is to be found in rivers and streams everywhere. Naturally, certain regions are richer than others and this is why prospectors, like mushroom pickers, jealously guard their "hunting grounds".

It is out of respect for my colleagues, who have asked me not to reveal precise indications of the gold routes, and not wishing to be the direct cause of another gold rush, that I will say no more than that the Choco and Antioquia regions are the most favourable. I have known people who have found in these regions between 10 and 50 grams of gold each day, with the added bonus of discovering tiny alluvial diamonds and emeralds caught in their "canalon" (the antediluvian wooden instrument employed by the gold prospectors).

This precious yield can be easily sold at 15% less than the day's official gold price, but it could also be taken to Europe or America and refined there.

If you have a little time left at the end of your stay in Colombia, pay a visit to the Gold Museum, which contains the world's largest collection of pre-Colombian jewellery and ornamental objects. Over 25,000 gold objects, displayed in a clear and rational manner. Upon request, they will show you a very interesting documentary and at the end of your visit prepare for a surprise: a darkened strongroom which suddenly explodes with light to reveal four walls literally and completely covered with thousands of gold jewels.

Sapphires and Rubies in Thailand

Although the Thai mines do not actually yield large quantities of rough stones, this country is nonetheless the most important in the world, if for no other reason than the exquisite way they cut these corundums. It occurred to me that an appropriate homonym would be: "Taille-land", the cutting country!

It is a well-deserved reputation, for Bangkok, in fact, receives batches of rubies and sapphires from Australia, Burma, Cambodia, Ceylon (Sri Lanka), China, Indonesia, Laos, Malaysia, Pakistan, the Philippines and Vietnam.

Paradoxically, a Ceylon sapphire sells at a much lower price in Bangkok than in Colombo! Not surprisingly, Thailand has become the most important centre of the ruby and sapphire trade, and in fact the market here offers exceptional opportunities for a bargain buy. Strong competition, the enormous quantity of merchandise available, the wide variety of quality and choice have contributed towards making this a privileged trading centre for professional and chance buyers alike.

Whatever the French merchants might say, it is now an undisputed fact that the gemstones purchased in Bangkok are qualitatively on a par with those available in Europe. However, accidents do happen, and inexperienced tourists could be tempted to buy gemstones in circumstances that are anything but professional. Naturally, these stones would later prove to be artificial and, how about this for irony, made in the Jura mountains (France) of all places!

There is a high standard laboratory in Bangkok, located in a school of gemmology, namely the Asian Institute of Gemmological Sciences (AIGS), worthy of comparison with top western establishments. They will be only too willing to provide a certificate of authenticity, even before you actually buy a stone. The school takes students from all over the world, and I have met personally many Europeans who have studied at this institute, which was founded by a family of Chinese jewellers, the Ho family. The diploma awarded at the end of the course is recognised the world over.

Buying gemstones in Thailand today no longer involves the risks it used to. In fact, you are more likely to run into trouble in Europe where, for instance, certain highly reputable establishments have surprised investors by unexpectedly declaring bankruptcy. This was the case recently with Chaumet, the famous jewellers of Place Vendome founded in 1780. But even in Thailand there are rules; if you

Gold jewellery its in one of the many shops of ist kind in Bangkok's Chinatown.

follow them to the letter you will have no difficulty in recognising and avoiding the frequently obvious pitfalls. There are places to avoid at all costs and others, little known to the public, that are well worth a visit.

When to visit Thailand

The best time to visit Thailand is from November to June, after the rainy season, when the average temperature is 27°C. This cool, dry

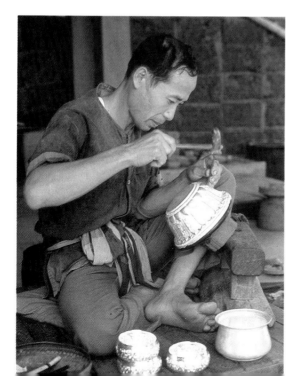

Thai craftsman embossing silverware by hand.

season is the Thai winter. However, there is no reason why you should not visit the country during the other months, provided you do not mind the unexpected tropical storms and torrid heat.

Where to stay

In Bangkok the choice is vast and prices reasonable. But remember, the Thai people attach considerable importance to where you actually stay, because the hotels are viewed as a measure of your financial status. If you stay in a small, cheap hotel you will never make a profitable transaction. But even boasting 5-star accommodations, you may be met with diffidence, so care is needed to strike a happy medium.

What to buy in Thailand

You will find everything in this fantastic country, from local products to imports from the United States, Japan and China, often available at a better price than in the country of origin. The secret of the Thai merchants is that they are content to make just a small profit.

All manner and quality of precious stones are to be found here, in particular rubies and blue and yellow sapphires. Also many other gemstones such as alexandrite, beryl, jade, opal, pearl, all varieties of quartz, spinel, topaz, tourmaline. Not all come from local mines, but they are cut in Thailand by expert craftsmen.

Local handicrafts are of exquisite beauty: gilded helmets and masks covered with sparkling mosaics, carved wood, engraved silver, burnished bronze, not to mention the silk. These objects can be purchased almost everywhere, in the streets of cities and villages alike.

But this is not all! Thailand is also a paradise for imitation goods. On practically every street corner there are stalls brimming over with sweat shirts bearing such prestigious trade names as Lacoste, Cartier, Dior, Yves St Laurent and Ralph Lauren, all for the same price of 60 baths. The imitation watches are instead "Swiss made" by Rolex, Cartier, Ebel, Dunhill selling for an initial price of 500 baths, which can be bargained down to 300! It is pointless to try to bargain further, for this is the minimum price set by the manufacturers, who pay the traders 25 baths for each item sold.

It goes without saying that all these goods are poor quality...and of course illegal.

Where not to buy

At tourist spots and beaches you are quite likely to be approached by smiling-faced young people offering you coloured stones at bargain prices. Do not be mislead by their amiable appearance, the stones are all imitation, even if they do cut glass, as the seller will be only too eager to prove. Synthetic stones are, in fact, as hard as the natural minerals, especially if they are made in Europe. Your indifference will then prompt the seller to try a second test which consists of pouring a little petrol on the stones and setting fire to it. This is his downfall, for natural gems will crack when subjected to sharp changes in temperature due to hidden flaws and fractures, whereas synthetic stones, heated in a furnace during the manufacturing process, are obviously heat resistent. But the poor fellow does not know that you are aware of this minor detail!

There is a street in Bangkok, Soi-Wanit, renowned for imitation and poor quality gemstones. Keep away. Also, I would not advise you to visit shops displaying jewellery and gemstones together with other types of merchandise. It generally means that the shopkeeper does not have his own workshop and therefore buys his goods from someone else.

Avoid the jewellery and gemstone supermarkets recommended by the hotels and travel agents. You will indeed see craftsmen at work before you enter the salesroom, but it is all an act, for the quality of the items on sale at these places is very poor. Leave them for the gullible and the shopping fanatics (after all, it serves them right...).

Lastly, if you are visiting the Chanthaburi and Kanchanaburi mines, you might be offered moderately priced rubies and sapphires. They are, however, of interest only from a minerological point of view. In reality, the finest gemstones and those of a ccrtain size do not stay long in the hands of the miners, but are sent at once to Bangkok and sold to professional merchants.

Where to buy

Bangkok is also known as Makok, city of the olives, or Krungthep, city of the angels. Personally, I prefer the name of Ratanakosin, or jewelled city, which I think is particularly apt. And well-earned, too, for everywhere you go you will see jewellery and gemstones. One out of every two shop windows displays precious objects and once I even saw gemstones being sold in a chemist's!

The most famous gem merchants are located in the Silom-Mahesak-Suriwong area. I am sorry to disillusion you, but here you will see no jewellery and no gemstones. There is nothing to see but old closed-down shops and shuttered windows. The typical breezy tourist in tee-shirt, shorts and gym shoes does not come here because, in his opinion "there is nothing to see". What he does not know is that behind the shabby facade live the the great corundum kings. To meet them you must have an introduction.

During my first visit to one of these merchants, I was greatly struck by the strange ambiance, which I will try to describe. The ground floor was divided into two parts: the first, a sort of garage, housed an old Rolls Royce, a Porsche and a motorcycle; the second was where the caretakers lived.They seemed to me to be on a never-ending picnic seated around a simmering pot of some delicious smelling conconction. Steps led up to a mezzanine floor converted into a menagerie where I actually saw with my own eyes numerous monkeys, a black panther and a lion cub wandering about in a kind of mini hanging garden. On the first floor were the administrative offices: accounts department, telex and several computers. Incidentally, on entry the Thailanders must remove their shoes, but foreigners are not obliged to.

The second floor was comprised of six offices where customers were received. After my visiting card had been checked, I was invited to go up to the third floor, where I was admitted to the chief's presence in a scenario more suited to a marine biologist than a dealer of precious stones. The room was full of aquariums containing fish of every imaginable species. At the end of our talk the safes were opened and the table in front of me strewn with a myriad of precious gemstones. I had only to take my pick...

These then are the people to whom you must go to be sure of making a successful buy. They do not sell jewellery, only gemstones; but you will always receive a warm reception. In fact, they are less interested in concluding a deal with a foreign customer than in exchanging a few words with him about western customs and traditions and the difference between European and Asian cultures. These people have a deep affection for the countries of Europe, but no longer dare to visit them having in the past been the victims of considerable and unwarrented disparagement.

If you really are interested in buying jewellery, you must go to one of the high class jewellers located generally in the new shopping centres currently being opened throughout the capital or in the hotel

shops. However, you will have to pay tourist prices which might or might not be convenient, depending on where you live in Europe.

In Chinatown you will be able to find a selection of 21-22 carat gold jewellery, mostly bracelets and chains. They may be either hand or industrially made, not particularly well finished and sold by weight with just a small supplement for the manufacture. It is always better to choose the hand made articles as these are slightly cheaper and a little more original. The other jewellery is generally an imitation of Italian designs and is more expensive.

A visit to the Thai mines: the thrill of real adventure

Once you have visited all the usual tourist attractions, the Royal Palace, the floating markets, the crocodile farm, the gold and emerald Buddhas and so forth, may I suggest a touch of true adventure.

A visit to the ruby and sapphire mines, which only Thailand has to offer. They alone are worth your trip to this fascinating land. And I would advise you to go as soon as possible, as it is likely to become increasingly difficult in the future.

Kanchanburi

You can look forward to an unforgettable experience. Kanchanburi is a city situated a few hundred kilometers north east of Bangkok. I suggest that you leave the capital no later than 8 am, so that you can be back again before 8 in the evening.

Of course, the main purpose of your trip is to visit the ruby and sapphire mines, located close to the Burmese border, but take a little time, too, to visit the spectacular Sai Yok falls and the famous bridge on the River Kwai, both in the immediate vicinity of Kanchanburi.

From Bangkok, you take the road for Thon Buri, then for Nakhon Pathom (site of the oldest shrines in Thailand) and lastly for Ban Pong. You will find the trip more enjoyable if your party is not too large and if you take with you a local guide who knows the region and the way to these archaically picturesque mines.

The miners themselves are extremely hospitable and greet all visitors warmly.

It is by no means unusual for them to offer some of the rough stones as they are extracted from the mine. Incidentally, they love to be photographed.

Chanthaburi

On the other side of Bangkok, to the south east, close to the Cambodian border, lie the Chanthanburi mines.

Your visit there can be made doubly enjoyable and I will explain why. It is difficult to go to Chathanburi and back all in the same day; and so I suggest that you take a day and a half or even two days to do it, for it is well worth while. You could leave Bangkok in the morning, taking the coastal road that skirts the Gulf of Siam and spend the afternoon and night at Rayong, Ban Nong or Ban Phe, three splendid resorts with hotels overlooking the sea. Chanthanburi is only fifty kilometers further on.

These resorts offer a variety of sports activities and delicious sea food; lobster is as easy to find as a plate of French fries! Moreover, you will have no trouble in finding a professional guide to take you on to Chanthanburi.

Chanthanburi is also known as the "City of the Moon" because of certain stones with moon-like reflections found there. Some 70% of the rubies and sapphires mined in Thailand come from this region.

The trip through the jungle is generally made in a light truck or jeep, though some guides prefer to use elephants, and for good reason, for this is by far the most efficient form of transport. Take advantage of the trip to visit the canyons of King Taksin and the Nam Tok Phliew falls. Then on to the highlight of your trip, a unique and unforgettable experience. Under no circumstances forget your camera.

As I mentioned earlier, the miners often offer their visitors rough stones as souvenirs. Accept their gift and repay it with a packet of cigarettes or a small tip for the head miner who will then share it with his assistants.

The Thailanders

It is by no means an accident that Thailand is known as the "Land of Smiles". Despite the poverty of their existence and the problems they must face each day, the Thais are always cheerful and happy with the little they have. Foreigners who respect their habits and traditions are given a wonderful welcome. It is never wise to criticise their regime, for these people are deeply fond of their king and queen. The foreigner who understands all this will win their admiration and respect. Not so if you behave like those ignorant, arrogant westerners who see Thailand as a conquered country. Thailand has

never been colonised and a supercilious tourist is certainly not going to change things.

The people are courteous and polite, but do not take advantage of this fact, for they are not to be defied with impunity. Above all, do not mistake courtesy for servility. Ask whatever you wish, but do it politely!

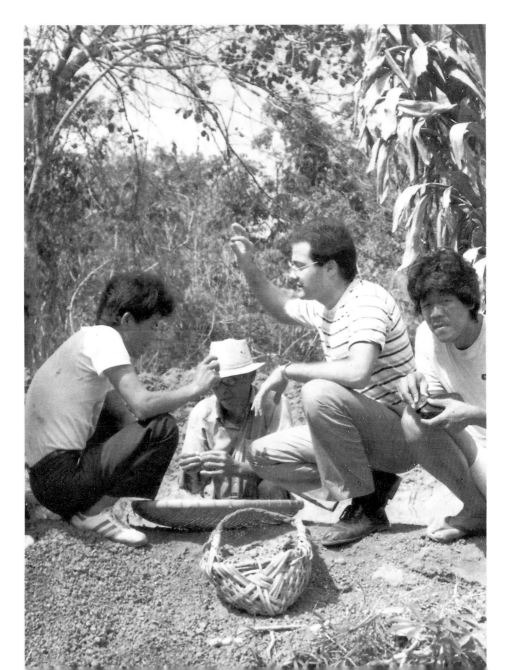

On your way to Kanchanaburi, set aside a little time to visit the spectacular Sai Yok and Nam Tok Phliew falls.

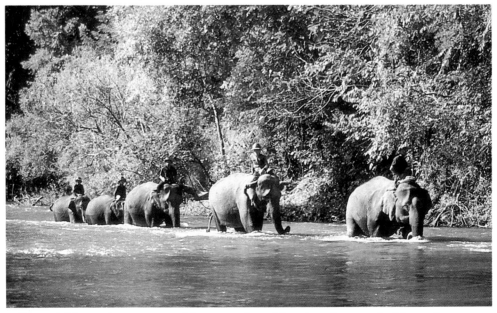

Some guides prefer a more exciting way of reaching the mines, and with good reason, for an elephant is a far better way of crossing the jungle than a jeep.

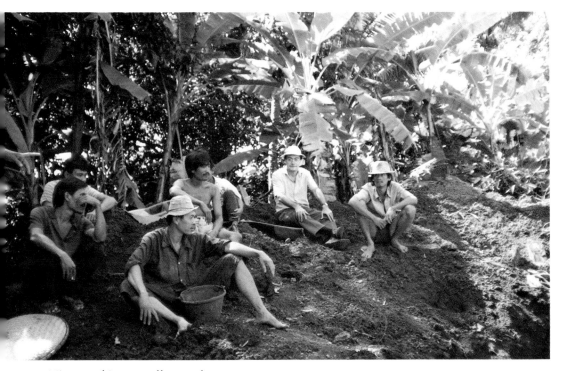

Miners taking a well-earned rest.

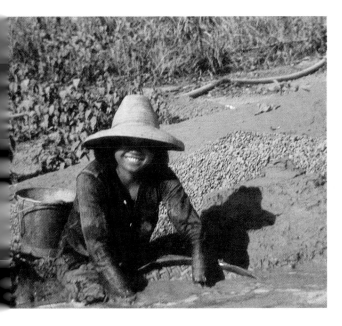

The Land of Smiles. Despite the hardships of everyday life, the Thais are indeed a happy people.

135

Semi-Precious Gemstones at Idar-Oberstein

Idar-Oberstein is a city of western Germany, not far from the French border. It specializes in the cutting of semi-precious stones. There are several thousand workshops and shops offering every imaginable variety of rough and cut gemstones, to meet the requirements of professionals and tourists alike. Idar owes its reputation in this field to the fact that its soil was once rich in many different types of semi-precious stone, in particular agate.

The raw materials have long been depleted, but the science of cutting them is as alive as ever. Work techniques are excellent, if not perfect. Many countries have tried to compete with Idar, always unsuccessfully. Unfortunately, prices are slightly higher here, due to the cost of labour in Germany and the strength of the mark. However, if you are looking for a beautifully cut semi-precious gemstone, this is the place to go. But remember, just like anywhere else in the world, there are reliable and less reliable merchants, and so you need to know where to go first.

Idar-Oberstein is well worth a brief visit for it offers many tourist attractions, not least among which the Heimatmuseum.The museum has twenty-one rooms in which is collocated the heritage of 400 years of craftsmanship. The most interesting rooms are those containing the tools used by the goldsmiths of the past and an equally old lapidary's workshop. Then there is the famous "room of crystals" in which are displayed some of the world's largest specimens. Yet another room houses a collection of extremely rare phosphorescent minerals. The museum has one other surprise in store for its visitors, moldavites and tecktites originating from outer space.

Another museum, opened recently, is located in the same building as the Stock Exchange. It contains an interesting collection of starstones, including one that is the size of a tennis ball. You may also walk along a sort of blind corridor leading to an enormous safe in which are kept the treasures of the museum.

No visit to this city would be complete without a look at the agate coins minted in Idar for the governments of Senegal and Sudan. Right nearby, and well worth seeing if you have time, are the Oberstein castle and Felsenkirche, the latter being a church cut directly out of the mountain and unique of its kind.

Idar-Oberstein has recently inaugurated a special service for tourists interested in learning more about the activities of this city

and gemstones and jewellery in general. Brief introductory courses for beginners are organized at the lapidaries' workshops, and often include visits to the abandoned mines close to the city. For further information, write to: Stadtisches Fremdenverkehrsamt
Postfach 01 1480
D-6580PO Idar-Oberstein (Germany)

Pearls in Japan

Up until now my advice has always been that it is better to buy precious stones in the country of origin. With pearls this is not the case. To buy pearls in Japan will only be a viable prospect if you are visiting the country for other reasons, or if you are intending to invest a considerable sum of money. Otherwise the price of the air ticket and the extremely high cost of living in Japan would virtually cancel out any eventual saving.

Moreover, it is almost impossible in Japan to buy directly from the pearl growers or wholesalers. In all events, pearls can be bought from jewellers for slightly less than in Europe. So your one possibility to make a profitable transaction would be to buy a complete necklace of top quality pearls on the occasion of an already-planned trip to Japan. Always choose the top quality, which is to be found only at the high class jewellers, and sold with a guarantee.

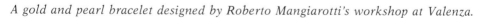

A gold and pearl bracelet designed by Roberto Mangiarotti's workshop at Valenza.

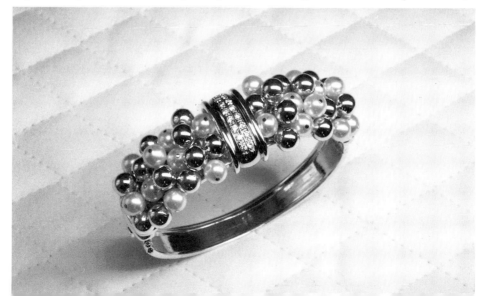

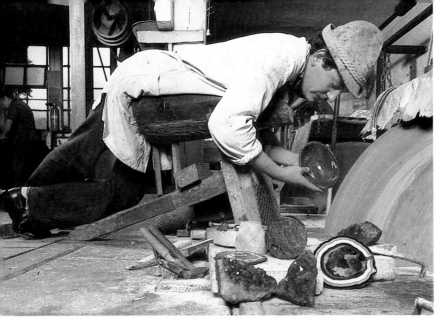

A back-breaking job. Uncomfortable as it may seem, lapidaries have to work in this position in order to avoid serious back problems.

A mythological scene sculptured in coral. This rare ornament is part of the Capuano of Via Veneto collection in Rome.

Some of the wonders of the Heimatmuseum in Idar-Oberstein.

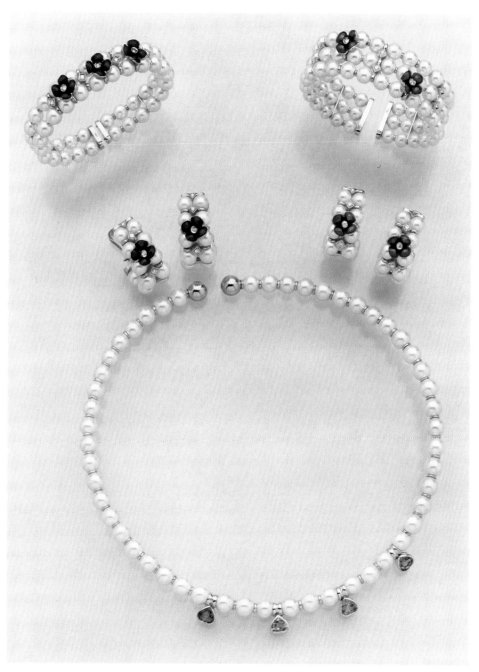

Gold and enamel necklace, earrings and bracelets decorated with diamonds, semi-precious stones and pearls created by Ermes Marega and Luciano Cortelazzi.

Coral at Torre del Greco

I need hardly remind readers of the importance of this town in the production of coral. Everyone knows that Torre del Greco is unique in this field and that the master craftsmen who work here are the most skilled in the world. At their workshops you will find corals of every imaginable quality, shape and size.

A word about price. You would be wise to enquire at more than one workshop before making a final decision. For it is always a good idea to encourage competition. Remember, however, that coral is rapidly becoming extinct due to pollution.

Your good-luck gemstone			
January	Garnet	*July*	Ruby
February	Amethyst	*August*	Peridot
March	Aquamarine	*September*	Sapphire
April	Diamond	*October*	Opal
May	Emerald	*November*	Topaz
June	Pearl	*December*	Turquoise

One last piece of advice

Just in case you are thinking of organizing a trip to one of the countries mentioned in this book, I have prepared a list that will give you a clear idea of the stones you will be able to find in each country and their availability.

I advise you not to spend too much money, because as a rule in these countries merchants see tourists as an opportunity to palm off average quality specimens at prices higher than those normally asked.

Each of these salesrooms and stores has what I call a "temptation window", the aim of which is to encourage unsuspecting tourists to embark on a spending spree. The gems and jewellery on display are marked at wholesale prices (and sometimes less) to encourage people to enter the shop. I need hardly add that if you buy only the bait you will have made a good purchase, but if you buy more you will most surely have been caught!

The wisest course of action is to visit all these shops, however long it takes, buying only the "bait" at each place. In this way you will accumulate a valuable legacy at very reasonable prices, and visit exotic places at the same time. Do not forget this simple little trick the next time you go away.

Destination	Gemstones found or worked there	Buying possibilities
Afghanistan	Lapis lazuli, Agate, Ruby	Currently nil
Australia	Opal, Topaz, Garnet, Peridot, Agate, Pearl, Sapphire, Zircon	Fairly good
Brazil	Emerald and all semi-precious stones	Very good, but of little interest (poor quality)
Burma	Ruby, Kunzite, Alexandrite, Jade, Peridot, Moonstone, Sapphire	Difficult and dangerous
Ceylon (Sri-Lanka)	Sapphire, Alexandrite, Garnet, Peridot, Moonstone, Chrysoberyl, Topaz, Andalusite, Zircon	Good but expensive
Chile	Lapis lazuli	Normal for the quality available
China	Jade, Agate, Quartz, Lapis lazuli, Aquamarine, Coral (also antique Jade)	Rather difficult
Colombia	Emerald, Aquamarine	Excellent but dangerous
Congo	Malachite, Ivory, Peridot, Diamond	Poor
Egypt	Turquoise, Emerald	Poor
Hong-Kong	All semi-precious stones and Pearls	Very good
India	All precious and semi-precious stones	Difficult and not to be recommended
Iran	Turquoise	Rare
Madagascar	All semi-precious stones, especially Tourmaline	Good
Mexico	All semi-precious stones, especially Opal	Good (caution needed)
Russia	All semi-precious stones, Emerald, Diamond	Still poor
Singapore	All semi-precious stones, Pearls	Excellent
South Africa	Diamond, Peridot	Very few
Thailand	All semi-precious stones, Ruby, Sapphire, Pearls	Exceptional
Zambia	Emerald	Difficult

This elegant palm-brooch can worn to equal effect by both men and women. Dreams and boundless freedom is the idea evoked by Stefano Michelangeli-Polimeni, inventor of the "style volage".

Giving Jewellery for Special Occasions

- Flowers are beautiful *but* last no more than a few days.
- Clothes are useful *but* are expensive and wear out.
- To give money is practical *but* dull and unimaginative.
- Ornaments are exceptional *but* far too personal.

Presents without a "but" are books, which, for not much money, enrich the mind, and jewellery, which, for very varying sums of money, embellishes the human body.

To give jewellery is to give something of exquisite beauty that will last forever. There is no lack of opportunity.

Births

A never-to-be-forgotten day, for both mother and child. The mother should receive the most important gift from her husband: a bracelet and earrings to match her engagement ring, for instance. The in-laws could give a brooch or pendant, matching the gift chosen by the husband.

The birth of a second child is the occasion to add to the parure: necklace, watch.

Traditionally, the baby is given a gold bracelet or locket and chain. Experience tells me that this is not a good idea, for people are always bringing me these objects to melt down.

My advice is to give a baby boy a gold ingot (you can find them weighing as little as one gram) and a baby girl a precious stone.

I am sure they will thank you when they are old enough to understand, whereas they probably would not know what to do with a bracelet or locket.

Christening, First Communion and Confirmation

As a rule, on these occasions, boys are given gold medallions or crucifixes and girls pearl or coral bracelets.

Here again I think it is a better idea to think of the future. Boys are far more likely to appreciate a gift of gold or silver coins, either modern or antique, and girls gemstones or loose pearls (provided they are of the best quality).

Coming of age

For a young lady the ideal gift is a string of pearls or coral, and for a young man a gold tiepin set with a small coloured gemstone or diamond. For such an important occasion, the organic gems should be of the very best quality and the young man's ornament the work of a highly skilled craftsman.

Never forget the day you met

Even though people tend to attach little importance to this particular date it is, in my opinion, one to be remembered for it marks a turning point in our lives. What better way to keep the memory of this day alive than with a little gift from each one of you to the other. A keyring or pen, for instance, ideal for either; or, if you prefer more personalized gifts, earrings for her, cufflinks for him.

Engagement

There can be no doubt as to the gift a young man will give to his fiancée on the day of their engagement. It has to be a ring composed either of diamonds alone or of a coloured gemstone and diamonds.

It is a young man's first really serious gift to his fiancée, so the choice is highly important. And strictly personal. Everyone loves a surprise but in this particular case it can lead to disappointment. Better not run risks. A young lady would be wise to give her boyfriend some idea of her taste in jewellery, perhaps pointing out in a shop window the things she likes and dislikes. Afterwards, it is up to the young man to remember and take into consideration exactly what she has said: the colour gold, the type and colour of the gemstone, the cut, shape and size, bearing in mind of course the size of the hand that is to wear the ring. In this way the gift will be a surprise but not a disappointment, and the mutual understanding thus

formed between two young people is a mark of respect that represents an initial step towards securing the bonds of harmony so essential in married life.

Wedding

This is the best day of all to give a diamond ring, so do not let the opportunity slip by. You will find a range of rings to choose from, with the stones either brilliant, marquise, square or baguette cut, set either lengthwise or breadthwise. Choice will depend on personal taste and, of course, your pocket; and, in this respect, remember that even a half circle of stones can be equally attractive. For the man, there are some attractively plain designs available today, their originality depending on the actual shape of the band and the colour of the precious metal employed. Avoid anything with sharp edges as this implies poor workmanship.

Wedding Anniversary

I think you will agree that to follow tradition to the letter would, in some cases, be more of an insult than a mark of affection! With the exception, of course, of the years written in italics in the following table. For the other, less fortunate years, why not ask to be given gemstones for a piece of jewellery that you yourself design and have made at a later date. For instance, on your first anniversary ask for a sapphire, or other gemstone of your choice, on the second the diamonds to surround it and on the third have them set to your own design. In the end you will have a valuable ornament instead of a lot of poor quality jewellery that you will soon tire of.

Each year has its own tradition

1 year: *cotton*	8 years: *poppies*
2 years: *leather*	9 years: *pottery*
3 years: *wheat*	10 years: *tin*
4 years: *wax*	11 years: *coral*
5 years: *wood*	12 years: *silk*
6 years: *powder*	13 years: *lily of the valley*
7 years: *wool*	14 years: *lead*

Marcello Garzi's famous gold (or silver) pochette looks smart even on this ladies' suit.

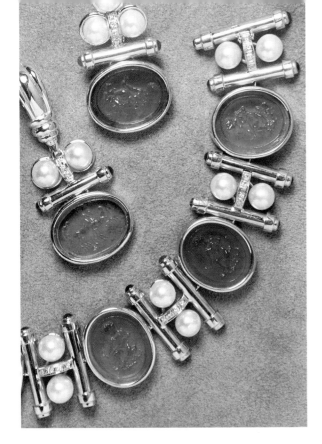

Cameo-worked pressed glass as created by Ansuini are absolutely unique.

This is just one of many attractive items from Marcello Garzi's special line "keynotes of success".

147

15 years: *crystal*	36 years: *muslin*
16 years: *sapphire*	37 years: *paper*
17 years: *roses*	38 years: *mercury*
18 years: *turquoise*	39 years: *crepe*
19 years: *cretonne*	40 yeras: *emerald*
20 years: *china*	41 years: *iron*
21 years: *opal*	42 years: *mother-of-pearl*
22 years: *bronze*	43 years: *flannel*
23 years: *beryl*	44 years: *topaz*
24 years: *satin*	45 years: *silver-gilt/vermilion*
25 years: *silver*	46 years: *lavander*
26 years: *jade*	47 years: *cashmere*
27 years: *mahogany*	48 years: *amethyst*
28 years: *nickel*	49 years: *cedar*
29 years: *velvet*	*50 years: gold*
30 years: *pearls*	55 years: *orchids*
31 years: *sheepskin*	60 years: *diamond*
32 years: *copper*	65 years: *rosewood*
33 years: *porphyry*	70 years: *platinum*
34 years: *amber*	75 years: *alabaster*
35 years: *ruby*	80 years: *oak*

Mother's Day

For those of you lucky enough to still have your mother you should not forget this day.

During the year, if you have the opportunity, take note of the things she seems to stop and look at when out shopping, or the things she mentions not having. If she has the right kind of hair, a decorative hairpin makes an unusual and useful gift. The classical brooch or pendant are equally suitable.

For the not so young Mums, may I suggest a touch of class, which I am sure will be appreciated. A gold-framed lorgnette or eyeglass.

Father's Day

Here, the choice is so wide that you could have quite a hard time in choosing. From gold blazer buttons to cufflinks, from keyrings to tiepins, or one of the very latest things in personal adornment such as a gold or silver pochette. Whatever your gift in this line, it is sure to give pleasure.

Birthdays

Families with a long-standing tradition often use birthdays to give one of the family jewels, which will in turn be handed down by the receiver to her children. For a man, the choice would be from one of the objects described in the preceding paragraph. Remember, it is always a good idea to plan ahead and buy a set of objects that match. These could then be given one by one on birthdays and other similar occasions.

Easter

There are many chocolate manufacturers now who will let you put your own gift inside an Easter egg. Think of the surprise at finding a string of pearls or coral instead of the worthless trifles you usually find.

Christmas

At this point you would be quite justified in arguing that after all these occasions there is no further room for giving precious objects. Justified yes, but mistaken! And I will explain why. Firstly, there are three distinct categories of jewellery:

- Jewellery for special occasions, which will only be worn once or twice a year. This type of jewellery is very valuable and best kept in the bank when not needed. These are often objects that have been in the family for generations and are part of its heritage.
- Jewellery of a certain importance for wearing at cocktail and dinner parties.
- Every day jewellery which, as the term implies, you wear during your normal daily activities and at work.

So for Christmas, why not give some thought to this and decide in which category you are lacking, and ask for something in this line. Christmas is a time when surprises are expected and what better gift to hang on the tree than a pair of earrings. They are particularly popular at the moment and moreover are the ornaments most visible during the winter season when most of our body is covered up.

New Year

In many countries of the world it is a family custom to put small gifts under everybody's pillow on New Year's Eve. As this gift is meant to be a wish for prosperity throughout the coming year, it generally has some connection with money, such as a gold or silver coin.

Minitest

This simple little test will help you choose the metals and gemstones best suited to you, their colour and their shape.

Choose one item from each section (A, B, C).

A. If you have chosen

Moon
You have a preference for white metals, especially platinum and palladium, though you are also attracted to white gold.

Mercury
Silver is your favourite metal, even though it tarnishes easily; in actual fact you find this characteristic particularly attractive.

Sun
Pure gold is without doubt your favourite metal. In this state it is relatively soft and for this reason must be hardened by combining with another metal. So you will have to be content with yellow or red gold.

B. If you have chosen

White
The colour of purity.
Qualities: a born artist, a poet at heart
Faults: fickleness, indifference
Gemstones: diamond, fabulite, zircon, pearl, rock crystal, mother-of-pearl, opal, moonstone.

Violet
The colour of strength and power.
Qualities: strong sensuality
Faults: decadence
Gemstones: amethyst, alexandrite, polychrome tourmaline, kunzite.

Blue
The colour of wealth born of perseverance and meditation.
Qualities: honesty, judiciousness, determination
Faults: obstinacy
Gemstones: sapphire, lapis lazuli, sodalite, turquoise, amazonite, blue tourmaline, aquamarine, blue topaz.

Green
The colour of a sensible, cultured person.
Qualities: refined taste, sincerity, respect for tradition
Faults: jealousy

Gemstones: emerald, jade, green aventurine, malachite, green tourmaline, peridot.

Yellow
The colour of the perfectionist and of ingenuity.
Qualities: a confident and intelligent thinker
Faults: impatience, tendency to provoke
Gemstones: yellow sapphire, topaz, citrine, beryl, amber, yellow diamond.

Orange
The colour of authority, of the leader commanding respect.
Qualities: a shrewd psychologist, he knows how to make himself popular
Faults: tendency to hide his true feelings
Gemstones: fire opal, sunstone, yellow sapphire, Chinese coral.

Red
The colour of kings and extroverts.
Qualities: boundless energy
Faults: agressive and violent
Gemstones: ruby, spinel, rubellite, coral, garnet.

Black
The colour of the enigmatic personality.
Qualities: intelligence, honesty
Faults: pessimism
Gemstones: black agate (onyx), hematite, cat's eye, sapphire starstone.

C. If you have chosen

The triangle
You are a mystical person: pear drop, marquise and triangular cuts are those best suited to your taste.

The square
Your predominate attribute is rectitude. Your favourite cuts are emerald, carré and baguette.

The circle
You are diplomatic, tollerant and adaptable. The ideal cut for you is the brilliant cut, though the cabochon cut is also well suited to your personality. You find round and oval shaped stones particularly attractive.

The Art of Wearing Jewellery

The mark of time

We normally tend to associate jewellery and gems with feminine appeal. And yet, if we look back in time to the dawn of civilization, we find that personal adornment was first used by man as an indication of virility, power and social position. Indeed, the male symbols of prehistoric man were "jewels" of bone or stone and, of course, weapons.

But they could not keep these fascinating ornaments away from women for long! Thanks to a sort of forerunner of modern feminism, these symbols of virility gradually became synonymous with charm and seduction. The men were left with rings, crowns and sceptres; and the jewel became the ornament of woman, par excellence.

Despite the shifting sands of time, this was how things remained up until the XIX century, when suddenly the desire was born to create culture with jewellery, the idea of turning these ornaments into an "art to be worn". As paintings and sculptures embellish an environment, jewels were to embellish the human body.

Ever since then the art of jewellery has been evolving. It is still slightly behind in comparison with the arts of painting and sculpture but nonetheless determined to catch up and even become a vanguard of art forms.

At this point one might ask: What is going to happen in the future? There seems little doubt that jewellery will remain a prerogative of feminine allure, an art to be experienced, an expression of the times, a precursor of fashion, a precious symbol, a world of ideas and surprises, cherished over the centuries, and that the art of jewellery is ready to develop in a burst of creative ideas.

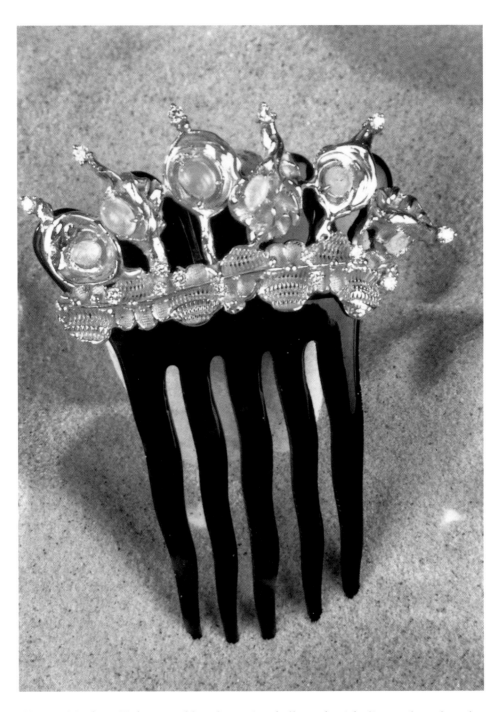

Simone Muylaert-Hofman: gold and tortoise-shell comb with diamonds and opals.

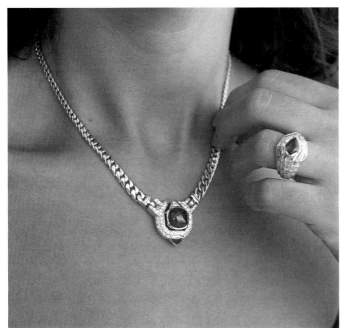

Well-chosen, well-worn jewellery undoubtelly accentuates the sensuality of the wearer. Gold necklace and ring with sapphires, rubies and diamonds created by Laurence.

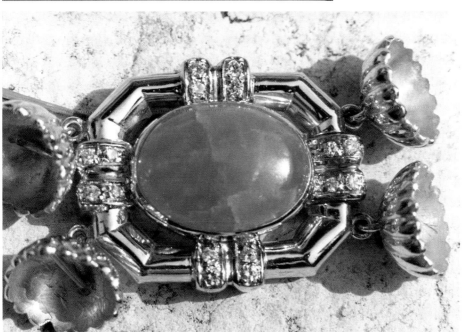

A clasp is often a jewel in its own right, sometimes even more striking than its necklace. This gold, diamond and pink quartz clasp is designed by Orolinea.

155

Why wear jewellery?

A beautiful room, with perfect, elegantly papered walls, is nothing but a hollow shell; it needs furniture, pictures and other ornaments to give it character, to enhance one's good points and, if necessary, hide its imperfections.

The same is true of the human body. Jewellery, skillfully used, will illuminate and enhance one's best features at the same time highlighting the personality of the wearer.

What a mistake it is to consider a piece of jewellery as a mere object, or to think that the same ornament can be worn just as easily by a mature woman as by a teenager, or by a special woman as by just anyone! Jewellery should be worn as an expression of the wearer's personality, created and chosen for this purpose. That is why there is different jewellery for women, men and young people.

Every woman should match the colour of the precious metal used to make the piece of jewellery with the colour of her skin, and the colour of the gemstones with that of her eyes. This harmony of body and adornment will give pleasure not only to the wearer, but to the beholder, too!

A beautiful jewel is a very sensual thing, polarizing the attention of all around. So, as you can imagine, it is extremely important, before buying and wearing jewellery, to take a good, critical look at yourself in the mirror. Earrings and pendants, for instance, must be proportionate to the size of your face, from the eyes to the mouth. In other words, jewellery should be chosen with care.

Gemstones too are indicative of personality, and not only their colour, but even their cut. A faceted cut is the expression of a strong personality, of determination and possibily agressiveness. On the contrary, the cabochon cut signifies a milder character, that of the romantic dreamer.

Feel at one with your jewellery

Your choice of jewellery must depend on your personality and state of mind, not on any temporary considerations. Whatever you choose to wear, it must become an integral part of you, an object in which you are so deeply reflected that your character, your emotions become one with its aesthetic beauty.

On the other hand, you should not totally neglect the rational aspects involved in the choice of a jewel. For instance, when buying

a bracelet for a young child, and considering the size of a child's wrist, one would automatically tend to choose something with small, fine links. But on second thoughts, you will agree that this does not take into account the tremendous vitality, the day-long desire to run, jump and tumble of a normal, healthy child.

So before you make up your mind, just stop for a moment and ask yourself: When am I going to be wearing this jewellery? What will it say about me?

Clothes and jewellery

However exclusive, however elegant, however expensive are your clothes, a jewel is far more valuable. And that is a fact!

For much the same price as a good quality dress you would be able to buy a jewel, with the difference that whereas the latter will last forever, the former is strictly related to current fashion, the seasons, and subject to rapid deterioration through inevitable wear and tear. So why on earth do we tend to choose jewellery according to the clothes we have and not vice versa?

Clothes lose part of their original value every time we wear them, not so jewellery. Not only will it outlive our clothes, it will also outlive those of generations to come! For the same initial sum of money, just try to compare for a moment the fleeting pleasure you would get from a new dress with the lasting joy of possessing a precious jewel. I am sure you will agree that the latter is in the long run a far better investment.

What jewellery shall I wear?

All jewellery can be divided into two main categories:

• *ornamental jewellery*, such as rings, necklaces, earrings and bracelets, which we assess from an artistico-aesthetic point of view;

• *ornamental jewellery serving some purpose*, such as cuff-links, tie-pins, keyrings and lighters, which we assess first and foremost from a functional and technical point of view, the aesthetic aspect being only secondary.

Over the centuries specific terms have been adopted to indicate sets of matching jewellery:

- *complete parure*: tiara, earrings, necklace, bracelet and ring. If you are also wearing a watch, take care to match the watch strap with the rest of the parure;
 - *parure*: as above, except for the tiara;
 - *demi-parure*: a complete parure lacking any one of the above mentioned pieces of jewellery;
 - *a quarter parure*: a complete parure minus two of the pieces;
 - *coordinate*: two matching jewels.

Thanks to certain intrinsic characteristics some jewels, more than others, enhance the sensuality and elegance of the wearer.

Having said this, here then is a possible grading:

1. A 60 cm long necklace and pendant.
2. Earrings.
3. A 40 cm long necklace.
4. Anklet.
5. A 50 or 70 cm long necklace.
6. A bracelet worn on the upper part of the arm, close to the shoulder.
7. A necklace over 70 cm long.
8. Ring.
9. Bracelet.
10. Brooch.

A similar ranking shows us that the most sensual of the gemstones is the ruby, followed by the diamond, emerald and lastly the sapphire.

Getting the desired effect

Rings Over the centuries rings have been used for many different purposes: as a seal, as an identification mark for certain secret societies, as a sign of the wearer's position in a power hierarchy. Not that this has in any way undermined the ring's primary function, that of accentuating the sensuality, beauty and elegance of a hand. An asymmetrical ring, for instance, worn with the longer part pointing towards the back of the hand, will make the finger wearing it seem longer and slimmer.

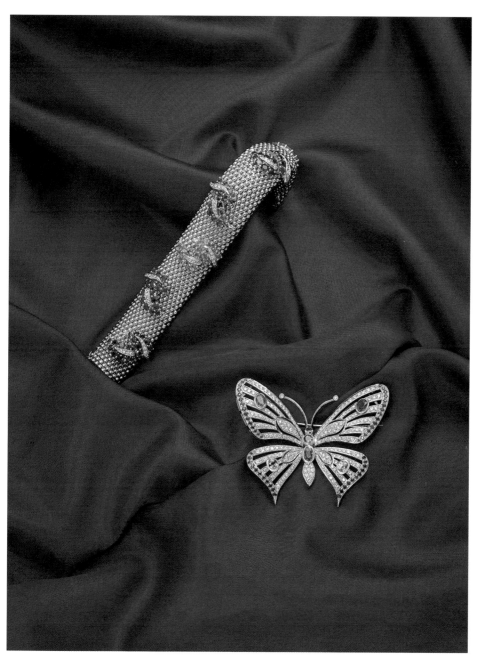

Nature has often been a source of inspiration for jewellery designers. Butterflies and bunches of grapes are the motif chosen by Pietro Acuto for this elegant gold bracelet and brooch.

The message inherent in a ring is of a social nature. A wedding ring worn on the third finger of the left hand needs no explanation; a solitaire is the engagement ring par excellence.

Necklaces A shimmering combination of gold and gemstones automatically draws the eye to the wearer's neck and neck-line, a part of the female body of unquestionable magnetism.

Earrings Earrings are the ornaments that most readily and immediately attract attention (even though, as we can see from the preceding paragraph, they are "only" second in our "seduction capability" scale). This is because they interrelate naturally with the light and colour of the wearer's eyes and also because they move with every turn of the head. Not only this, gentleness or aggressiveness, joy or sadness, these sentiments are transmitted at once by the type of earrings we wear.

We all have our preferences

Though we may not realize it, our choice of jewellery is instinctively governed by a series of parameters, such as colour, shape and design, which together constitute our "taste".

We apply these parameters whether we are buying for someone else, hence expressing in symbols the value of our affection, or for ourselves, where we are instead expressing the capacity for self-expression inherent in any act of buying.

In the same manner involuntary emotional and psychological factors come into play as do the environment and social sphere in which we live.

This all goes to show that buying jewellery is not as simple as it may seem. Cool, calm and collected is the attitude to assume when making your choice. However, what is even more important is your choice of a jeweller, who should be a person of sound reputation and considerable experience, able not only to assist you from a technical point of view, but with the capacity to appreciate your likes and dislikes and your temperament, and offer dispassionate advice accordingly.

Jewellery and fashion

Even though certain styles, such as Art Nouveau, have to an extent influenced trends in jewellery design, we cannot really say that jewellery follows fashions as does the world of *haut couture*. The designs created in the early years of this century are not only extremely popular today, but also highly prized by antique dealers and auctioneers. A necklace made in 1900 can be worn with the same effect today as when it was new. But who would think of wearing a dress 90 years old? Even if it has survived in a reasonable state of conservation!

Jewellery of 50 years ago is highly fashionable today, and will be so fifty years from now, on a par with contemporary designs. Currently, the *ne plus ultra* in elegance is a return to very ancient designs, Etruscan, Phoenician, pre-Colombian, or Babylonian, for instance, which, far from clashing, are especially effective when matched with modern accessories.

In other words, jewellery never really goes out of fashion like attire (try walking down the street wearing a flowered shirt and bell-bottomed slacks and see the funny looks you get!). If a jewel is beautiful it stays beautiful, even for two thousand years. Of course, we must distinguish between objects of value and the general bric-a-brac that is going to end up in the melting pot along with the gold chains and medallions given by all those well-intentioned relatives for your confirmation! At the risk of boring my readers, I cannot emphasise enough the importance of quality. Examine, evaluate and reflect with the same circumspection that you would use in choosing a painting for your sitting-room.

We could talk about prevailing trends as regards colour. For example, white gold enjoyed considerable popularity for many years, but today is hardly ever used alone, nor are pink or red gold. We generally find these tints used together. Yellow gold, which is the colour closest to pure gold, has never gone out of favour. Other interesting tints are green gold, a yellowish-green alloy obtained by mixing pure gold and silver, and black or blue gold, which are not alloys but gold that has been galvanized on the surface, sometimes resulting in an iridescent effect.

The production of jewellery falls into two main categories: the hand-made or artistic jewel, the fruit of lengthy research and verification, and the industrial jewel, manufactured in compliance with precise economic and commercial criteria. This second category does not come within the scope of this book, in that it is linked more to

the demands of the market than to fashion. Unfortunately, there are far too many people today who, through indiscriminate buying encouraged by unscrupulous jewellers, help to promote frivolous, passing fads such as zircons and other fake stones set in gold and reproduced into thousands of multiples. People do not realise that such ornaments, being worthless from both a technical and artistic point of view, are destined for inevitable destruction and are just money thrown away. On the other hand, no one in their right mind would think of comparing a poster with an original painting; so why should the same set of values not be applied to jewellery?

There is just one more point I would like to clarify about buying jewellery. It is often the case that a customer wishes to know not only the price, but also the weight of the gold used. This is a perfectly legitimate request as regards industrially manufactured jewellery, as it is the only part of the trinket of any appreciable value, but do please refrain from making this request if you are buying a hand-made ornament. This category is distinguished by three separate values: the raw materials, the workmanship and the design. To limit your interest to the value of the raw materials to the detri-

Ear piercing is a form of self-mutilation as old as time itself and goes back to ancient rituals bearing ornamental, aesthetic and religious connotations. Creso simulates this ritual with an earring that gives the same optical effect without actually piercing the ear.

ment of the craftsman's expertise, especially if you are dealing directly with this person, would be an insult indeed. When I was working in Paris I once showed a famous actress the door for having asked the weight of a certain ornament which she was later able to admire (and perhaps bite her tongue over!) on display in a museum.

This extract from a conference held by the internationally famous Italian fashion designer Nuccia Joppolo Amato, seems to me to give an excellent profile of jewellery through the ages.

"She wore a peplos more resplendent than the flames of fire/and was adorned with twisted spirals and bright flowers/her fine neck with magnificent necklaces of beautiful, graven gold..." (Homer, Hymn to Aphrodite).

Adornments fit for a queen, but not so very different from the gold worn by the women of ancient Greece and Rome. Ornaments in which gold reigned supreme. Necklaces, bracelets, earrings and fibulae (fibulae to hold their attire together, as seams had yet to be invented).

The predominance of gold in jewellery began to wane towards the III century B.C., with the introduction in the western world of exquisite treasures brought by Alexander the Great from his travels in Persia, India and Sarmatia: emeralds, rubies, sapphires, vitreous paste and semi-precious gemstones. The city of colour par excellence was Byzantium, literally covered in gold and gems. For over 1400 years Theodora and Justinian have been contemplating us from the walls of Ravenna, glittering idols more than human creatures, invested with gold, gems and pearls. This civilization of wealth and opulence was to remain fixed in our minds for generations to come, for at the close of the eighteenth century Gabriele D'Anunzio was to entitle his gossip column on the modus vivendi of the Roman aristocracy Cronache Bizantine *(Byzantine Chronicle).*

The florid style of the Baroque era led to a parallel development in the cutting of gemstones which had hitherto always been unfaceted. This in turn influenced the design of jewellery, and gems began to be used in abundance, as can be seen from the many official portraits of Spanish, French and English noblemen and women, bedecked in sumptuous attire, lace and jewellery glittering with precious stones and pearls. It is more than evident that rich clothes and jewels were a sign of rank.

Towards the middle of the eighteenth century there was a return to simpler styles, as the discoveries of Pompei and Herculaneum

began to influence the decorative arts. The immediate result was the classical Empire style, which imparted its inherent austerity not only to fashion but to jewellery,too.It was not until the advent of Romanticism that there was a return to the fancier tastes of Medieval and Renaissance art.

Rarely, however, is a re-evocation of past styles interesting from an artistic point of view. More often than not it resulted in clumsy, lacklustre imitations typical of the mediocrity of all nineteenth century decorative art.

With the turn of the century came the Belle Epoque, a golden age of prosperity which, in the jewellery trade, favoured the expansion of "aristocratico-commercial" establishments such as Fabergé. Their products were always of good quality, but from a stylistic point of view they were not prepared to abandon tradition totally in favour of avant-garde ideas, of which they absorbed just enough to maintain a balance acceptable, in their opinion, to the majority of their society set clientele.

The later art styles, Art Nouveau and Art Deco, were instead strictly against established concepts and imitation of the antique. They brought renewed vitality to jewellery, art, architecture and attire, the former with its floral designs, the latter with its geometrical shapes. Both were valued above all for their use of colour (Lalique, Fouquet, Veyer, Dunand, Despres).

The 1930s saw further change, thanks also to the inspirations of Coco Chanel, who revolutionised clothing and personal adornment with her fancy costume jewellery.These were years of well-designed jewellery and the introduction of new materials such as onyx, coral, opal, jade, precious and semi-precious stones coming from the colonies.

This was also the time of radical change in women's fashions: short hair, clinging dresses, long, dangling earrings and necklaces worn to emphasise a bare neck. During World War I and the years to follow, women began to take on work traditionally done by men, in factories, fields and offices alike. Some began to smoke, and shop windows soon began displaying elegant cigarette-cases ornamented with semi-precious stones, ivory and amber to meet the new demand.

In 1927 Jean Patou was the first fashion designer to embellish his models with high-class jewellery, while the invention of Mikimoto cultivated pearls virtually destroyed the value of natural pearls, apart from very large ones.

In the years immediately following World War II, fashion trends

came to a slowdown, as top designers began to take an interest in the art of jewellery. There were many different styles, almost always following current art trends, such as abstract expressionism, surrealism and so forth. New materials joined traditional ones: plexiglas, acrilics, brass, aluminum and many others, interesting perhaps from an experimental point of view but offering little scope for decorative development in the traditional sense of the term.

Small workshops became small factories, producing mainly for export. Diamonds were virtually the only stones suitable for this type of industrial and semi-industrial setup. The famous diamond-cutting workshops of Antwerp, Tel Aviv, New Delhi, Hong Kong etc. were hard at work cutting literally millions of stones, of all possible carats and all identical. There was a drop in the price of diamonds, while many other precious and semi-precious gemstones such as opal, aquamarine, true topaz, ruby, sapphire, dichroic tourmaline, lapis lazuli and jade, began to disappear. And if today for valuable fabrics such as cashmere, silk, embroidery and furs it is merely a question of cost, for coral, pearls and other gemstones the problem is far more complex (pollution and uncontrolled exploitation of the earth's mineral resources).

For many women this is perhaps the moment to start paying more attention to the things they wear. Fewer clothes, less jewellery, but well-made and of good quality. Jewels are a culture apart and we would all gain by a deeper understanding of them and of a handicraft that is slowly dying out.

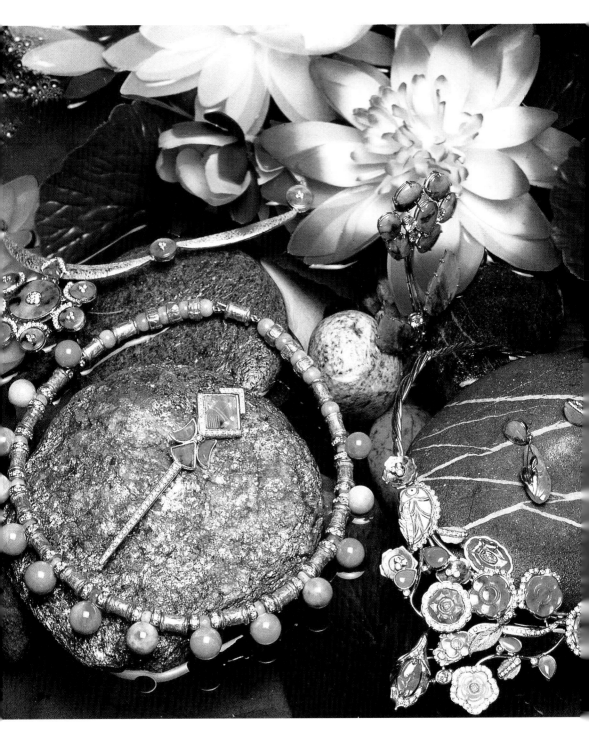

Matching gemstones with the colour of your eyes

The overall effect of a particular gemstone will be greatly enhanced
if it is matched, or in direct contrast, with the colour of your eyes,
a part of the human body which in fact resembles these precious

If your eyes are:	*They match with:*	*They contrast with:*
Black	Black Opal Onyx Labradorite Hematite Obsidian Cat's eye Marcasite	All stones except Dark Sapphires Pearls Coral
Brown	Garnet Carnelian Tortoise shell Smoky Topaz Pyrite Jasper Tiger's Eye Ruby	Yellow Sapphire Topaz Citrine Diamond Amber Heliodor Fire Opal
Light brown/hazel	Yellow Sapphire Topaz Citrine Yellow Diamond Amber Heliodor Tiger's Eye	Onyx Diamond Amethyst Sunstone
Blue	Aquamarine Blue Quartz Light Blue Sapphire Tourquoise Chalcedony	Diamond Dark Sapphire Lapis lazuli Sodalite Blue Aventurine Blue Tourmaline Alexandrite
Green	Emerald Chrysoprase Green Aventurine Peridot Jade Malachite Olivine Amazonite	Diamond Green Tourmaline Ruby Coral Rubellite Heliotrope
Grey	Pearls Moonstones Diamonds Grey Tourmaline	All stones

gems. Matching stones communicate a feeling of calmness and serenity, contrasting stones vivacity and high spirits.

Jewellery for men

This chapter would not be complete without a brief remark about jewellery for men, which is becoming very fashionable.

Men do not wear jewellery for the same reason as women, but simply because they like to, or to add a touch of class, perhaps. And why not? Adornments for men include:

- ring
- cuff-links
- collar pin
- tie-pin
- bank note clip
- chain and pendant

- bracelet
- watch
- key-ring
- pen
- cigarette lighter
- watch chain or keyring chain

These are all traditional objects, but others of more recent invention are now available for the more sophisticated man. In all events, like a woman, a man will choose jewellery and accessories in accordance with his personality. Nonetheless, in line with the dictates of good taste, he should not overdo it, but strive to highlight the elegance of his appearance without becoming showy.

Men's line created by Platinum Polo.

Contemporary Jewellery
and Future Trends

In my opinion, the jewellery of today is an art in the true sense of the word, on a par with painting and sculpture. It is certainly an art that goes its own way and is, in fact, well in advance of other forms of expression from a technical point of view. Unfortunately, it lags behind in artistic development.

These very different arts have a common denominator: size. A jewel is not much bigger than a few cubic centimeters. To achieve this dimension requires considerable brain work, skillful hands and a multitude of complex and less complex accessories. A sculptor, as he sets out to work, need have no fear of breaking the piece of marble from which he is to create a statue; likewise, an artist is not concerned with the amount of paint he uses. The art of jewellery-making is quite another matter. A master craftsman must plan his every move from the beginning to the end, for even the smallest error, in any one of the many phases, could prove fatal.

People actually risk, and sometimes lose, their lives to get these precious materials from the mine to the craftsman's bench. Understandably, it takes many years, patience, practice and integrity before a craftsman earns the right to work with them, and often to end up a victim of one of the typical risks of this trade. The position assumed during the setting of a stone causes damage to the spine and ruins the eyesight; the fine powders used for polishing can cause cancer; certain chemicals induce the onset of incurable allergies, not to mention the cuts and burns that are an almost daily occurrence. A jewel in its final stages can be reduced to a shapeless

"Moon" a gold and cabochon-cut amethyst ring by Marina Selvi. It bears a romantic similiarity to antique designs but is skillfully adapted to modern tastes.

Jewellery by Max. Brightly coloured rings decorated with some very unusually cut stones; a new approach to the art of jewellery making by a dynamic young designer from Valenza, Massimo Lenti.

Like sea-shells left on the sand by the receding tide, Marina Selvi's earrings are age-less. Though of ultra-modern design, they could just as easily be from Etruscan or Roman times.

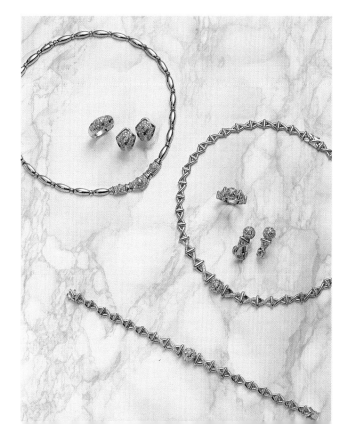

An original creation by Cafiso and Roda. The search for innovation is one of the manufacturer's primary objectives.

mass by too high a temperature, even a few degrees, as the last join is soldered. A priceless gem will become a worthless reject in a matter of seconds should it fracture in the craftsman's hands while being set.

Even though certain age-old procedures are still adopted, the technique of jewellery has today reached a technical level far superior to the other arts. Alongside traditional accessories we find X ray, laser and ultrasonic equipment, electronic microscopes and balances, vacuum-bottled gas for soldering, computer controlled production plants and so forth. Jewellery is a typical example of integration between rudimentary craftsmanship and advanced technology.

Unfortunately, from an artistic point of view, things have not kept pace. In my opinion, the art of jewellery is some fifty years behind in respect to the other forms of art. In the light of all this, it is not technique that inhibits progress, but rather two other equally important factors.

The first is size. It is very difficult for a craftsman to express to the full his creative genius with such a small object. Jewels are even smaller than miniatures, which are small enough! Moreover, approximately half the volume of the jewel is the supporting structure or connecting link between the human body and the ornamental motif.

The second factor is of an economic and social nature. Designers are constantly pressed to create goods that are easy to sell, in accordance with contemporary marketing dictates which tend to reduce risks to a minimum, to the detriment of creativity. This is a grave mistake, which hinders the progress of artistic development and leads to a vicious circle from which there is no escape, involving the designer, the manufacturer, the retailer and the consumer.

I will try to sum up as clearly as possible this situation:

- The consumer is only able to buy what is on display in the shop windows. This is normal.
- In the shop windows there is only a part of the merchandise offered by the manufacturers to the retailers. Rarely are they willing to buy new or novel designs, though they are continually asking for them.
- The manufacturers require their designers to create styles that will be acceptable to the retailers, which virtually leaves little or no scope for innovation, for fear that these yet unfamiliar ideas will be rejected by the average customer.
- Designers have stopped designing! They have little incentive to do

A design by Rodolfo Santoro for a necklace and brooch. There is no lack of new ideas, unfortunately they are not always accepted by the manufacturers who are often unwilling to abandon safer, traditional styles.

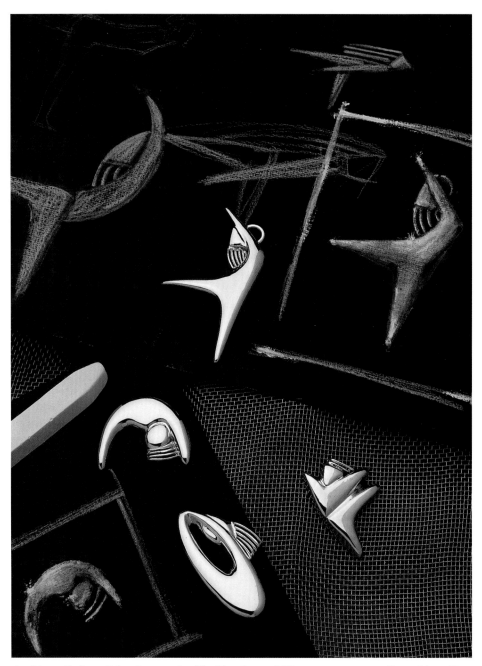

Architect Robert Celotti was asked by Trevisan of Vicenza to create a line of jewellery inspired by dance movements. The result was the "Danzelles", a set of gold brooches in a style extraordinary for its linearity.

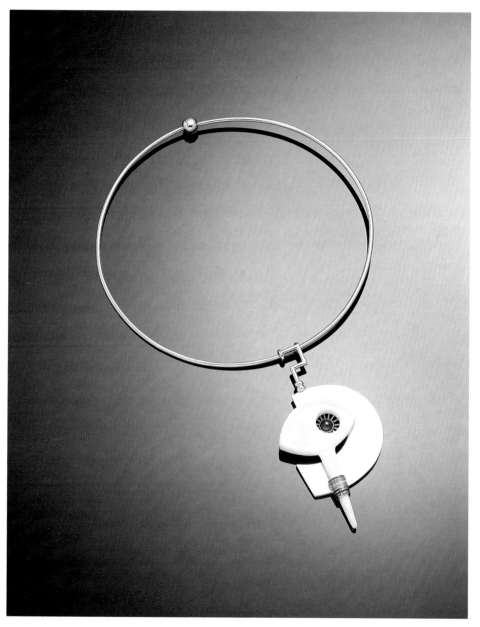

"Vigiling Human Rights" 1968. Choker with yellow gold, enamel and a sapphire cut en cabochon, featuring a naturally formed flint stone from the Po River. Created by the sculptor Paolo Spalla for Ferraris jewellers. Simple little stones do not suffer by comparison with gold and precious gems; for they, too, are products of nature and represent thousands of years of earth's history.

175

anything more than simply re-create what is selling already. Which inexorably cripples further artistic development.

The moral of this story is that customers cannot buy what they do not see in the windows, and designers are reluctant to introduce the novelty that buyers are waiting for as a change from mass produced monotony.

At this point, allow me to launch a double appeal. Firstly to the manufacturers, within whose power it is to break this vicious circle, by simply agreeing to make jewellery that is valid not only from an economic, but also from an artistic point of view. Secondly to the retailers, that they at last begin to do justice to this unique craft by displaying not only the easy to sell goods, but jewellery that has also a traditional (precious metals and gemstones), artistic and cultural value.

Just to prove that there are indeed designers who every day put their talent into the creation of new and original designs, I asked my colleagues of the Associazione Designers Orafi (ADOR) to allow me to illustrate this chapter with some of their most recent creations ,which, I must point out, have little chance of reaching the shops where the majority of my readers are likely to go.

To explore this problem more fully, I interviewed designer Rodolfo Santero, professor at the Art Design Tecnica, Institute of Milan, and winner of the 1973 edition of the Diamonds International Award.

What do you think of today's jewellery?

I do not feel that the jewellery of today meets the expectations and requirements of the public in general. The trade is negatively influenced by strong commercial interests. Current technology is such that there is no limit to the possibilities for innovation. In fact we have reached a point where theoretically we can do anything we want. Unfortunately, new technology calls for a strong initial economic effort.

What do you think will be the future trends in jewellery? Have you any particular wish for the future?

I think the general public will be better informed in the years to come. Consequently, it will not be long before people start asking for a more personalized style of jewellery. In other words, those who have only a limited budget will be able to find attractive, artistically valid jewellery made of inexpensive materials such as plastic and other non-precious materials. Those who can afford to spend

*Crocodile-skin
man's belt
with a gold
and diamond
buckle.*

*Taking his
inspiration from
Egyptian art,
Claude Wesel has
created this
"Pharoah"
necklace which
is made of gold,
steel, titanium
and rubber.*

more, but are equally keen for novelty, will be able to choose from items created with the more precious, rarer materials.

My only wish is that people learn to respect jewellery and its message, as they would respect all other forms of arts.

People should realize that exactly the same amount of work and effort, exactly the same procedures are involved in the creation of a piece of jewellery as in the architectural design of a house. If not more: volume and capacity equilibriums, physical-mechanical resistence, chromatic components, the psychology of forms and symbols, environmental application, use, and much, much more.

What do you think jewellery will be like in the year 2000?

My impression about the future is this: Firstly, people will tend to choose jewellery styles that, in shape, size and colour, best match their personality and physical characteristics, taking into account the composition of the materials from which the jewellery is made. Secondly, designers will increasingly look to the past for inspiration, adapting the elegant simplicity of these antique designs to the tastes of the coming century. There will be wide use of new materials, while gold, thanks to its unrivaled physical qualities and exquisite colour (which has always irrevocably linked it to the sun) will continue to be a major accessory. I see no reason why a diamond or precious stone should not be set in a fragment of some planetary material! The third millenium will demand the use of materials symbolizing the white light of space, with effects and emotions that could be kindled by platinum, for example.

Is this what you teach your students?

Of course, in that they will be the creators of jewellery as we step into the third millenium. I can only hope that the manufacturers of the future will appreciate their efforts and stimulate their artistic creativity. If this is so, it will be to the benefit of jewellery itself, the general public and this time-honoured profession.

What message do you have for the general public?

After having read your book, people ought to have the courage to demand and obtain jewellery that reflects their own particular zest for life (going through traditional sales channels and asking to meet the designer). Readers should categorically refuse to buy the ephemeral, mediocre jewellery that gets worn for a while then put aside in some drawer and forgotten about. People simply have to understand that buying jewellery is no different from buying any other work of art. It requires the same amount of care, thought and discernment to distinguish between the good and not-so-good offers. With the help of this book, the task will be much easier.

Selling Jewellery and Gemstones

Mine is one of the oldest families of jewellers in the world and right from my earliest childhood I have heard it said that to sell a piece of jewellery or precious stone successfully depends largely on how it was bought in the first place. In fact, when you sell, you will only recover the intrinsic value of the object. Taxes, shop expenses, advertising costs, commission are lost for good.

One of the aims of this book is to acquaint you with the rules of wise buying, which will save you disappointment in the future.

First and foremost, look the buyer straight in the eye! The more you can monopolize his attention, the more his interest will be aroused. And as the value he will attribute to the object you wish to sell depends to a large extent on his interest in it, you will see how important this apparently simple stratagem is.

Selling is no different from buying; there are places to go to and those best avoided. I will begin with the least favourable.

The HBJO

In France the HBJOs (Horologer, Bijoutier, Joaillier, Orfèvre) are at the top of the list. They buy jewellery as scrap metal, which means for the basic price of the precious metal. They then deduct the costs of refining the metal, and of the weight loss resulting from this operation, melting costs, State taxes and any other costs they see fit to invent. Frequently, their calculations are highly approximate and in the end they will probably offer you an all-in price, a very low one, of course.

The refiners

They too buy jewellery as scrap metal, but at least they have the decency (or tactlessness?) to dismantle the jewellery in front of you and give you back the stone. But they will again deduct refining costs and surplus value tax. The refiner will pay you on the spot and will not try to persuade you to buy from him, as the French HBJOs have the nerve to do. Undoubtedly, this is the best way if you want your money immediately.

The flea market

Here you are more than likely to find people with the ability to recognise the value of this or that stone, and if they are not actually interested in the jewellery themselves, they will be only too willing to advise you of other eventual buyers.

Normally, they will not deduct any sales tax, although this is only because they do not want the transaction to appear in their ledgers! And they prefer to sell the jewellery again, as soon as possible.

An ad in the newspaper

This is quite a good system for inexpensive jewellery, but should be strictly avoided if you wish to sell more valuable objects, for you never know, and the buyer who turns up on your doorstep could be a crook, a customs officer or even a tax inspector! Anyhow, it is sound policy always to receive by appointment and in the presence of a third party. In the advertisement, mention neither your address nor the price, but try to emphasise the quality of the object and your reason for selling it. The best reason is still "sudden departure".

The antique dealer

These are "cousins of the corporation" and, to avoid any risk of being "swindled", you would be wise to go only to those who have a reputation to defend. Just one little point, if you do go to an antique dealer, the sale will not remain a secret for long. In fact, these dealers exchange gemstones so frequently that your jewel will soon have been displayed in all the antique shop windows in town!

Auctions

The highest bidder takes the prize. A rather convenient formula which guarantees that the object will be sold for its full value.It is important, however, to choose the right time of year and a reliable auctioneer. This may sound superfluous, but I can assure you it is of considerable significance for the sale. In all events, do not forget the extra expenses involved if you do sell and, what is more important, if you do not.

Private sale

It might happen that the jewellery you wish to sell is of interest to someone in your family or immediate circle of friends. In this case, the most feasible excuse for wanting to sell it is that the object "brings back unhappy memories". In this way you will not be required to give any further explanation of your motives, which is always a delicate question for both seller and buyer.

Private exchange

I emphasise the word "private" to distinguish this type of transaction from a public exchange which I do not recommend due to the avidity of certain middlemen who, depending on whether you are the buyer or the seller, assume the role of "procurer" or "safeguard" of good deals.

Sooner or later, we all have the need to buy or sell something. Suppose you want to buy a friend's car. What is wrong with paying for it with a piece of jewellery you no longer wish to keep? A very simple, discreet transaction and gratifying for both parties concerned.

Old gold

We nearly all have odd bits of gold hidden away and forgotten about in some drawer or cupboard. These objects, broken chains and bracelets, coins of no numismatical value, gold fillings and so forth can all be sold to refiners of precious metals who, as I have already mentioned, will deduct any sales tax. This is really more a "depreciation", considering that you paid more for the gold initially than you are likely to get when you sell it.

181

A more practical proposition would be to use this old gold in part payment of other small items you wish to buy from your jeweller. Alternatively, you could give it to a jewellery maker to be used in the creation of a new jewel of your own choice. In this way, you will pay only for the design and creation of the object, and avoid all those ridiculous taxes and bothersome tax statements.

"Antique cut" diamonds

Cut them again or sell them as they are?

For the Belgians this is not a problem, for in Antwerp there are specialists who will indicate which is the more appropriate course of action. If you live in another country you could ask your jeweller the name and address of a specialized firm; or, alternatively, if you are in doubt and worried about making a fatal mistake, send the diamond to Antwerp. The experts will tell you if the stone should be cut or not. They will inform you of the cost, and the intrinsic value of the diamond before and after the "operation". There are centres specialized in this work.

I personally have seen stones the value of which doubled with cutting and other more ordinary ones which were increased in value by 15-20%.

The great advantage of Antwerp is that everything is done on the spot: the initial estimate, the cut, the second estimate and, if you wish,l they will also set the stone or sell it for you.

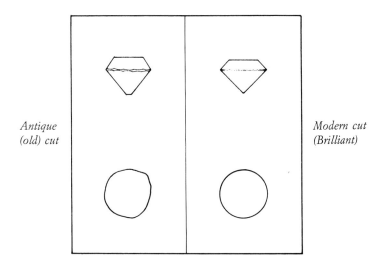

Antique
(old) cut

Modern cut
(Brilliant)

Disadvantages of a new cut
- the stone will lose from 20 to 30% of its original weight
- more than likely it will involve sending the stone to Belgium.

Advantages of a new cut
- the stone will undoubtedly have more fire
- the stone will increase in value and therefore be easier to sell.

One or two tips before selling jewellery

1. Old jewellery often needs repairing or at least renovating before it is sold. Most certainly do this; for you will then be able to ask a much higher price and more than cover the cost of the repair. As a rule, people tend to be suspicious of damaged jewellery, but luckily there are still some honest craftsmen to be found who repair jewellery well at reasonable prices.

2. The jewellery must be clean. To do this, first place it in a 10% solution of boiling ammonia (with the exception of emeralds, pearls and coral), then brush it with a soft toothbrush and a mild detergent. Lastly, polish it with a piece of buckskin or cotton. Emeralds and other delicate gems should instead be washed in lukewarm water and a mild shampoo. For pearls and coral the best thing is sea water or, in the absence of this, distilled water in which is dissolved some coarse-grained salt.

3. The object you are hoping to sell will certainly make a better impression if it is presented in its orignial case. If you no longer have this, find another one. It is not a good idea to wrap the jewellery in a piece of paper, or material, or a plastic bag. If you are selling more than one object, do not put them all together. Each piece must have its own case. If you lack the case, the next best thing is a square of buckskin or soft cloth.

4. It is essential to have the object you are selling evaluated before you take it to the prospective buyer, especially if it is very valuable. Make sure this is done by an expert and someone who has no involvement whatsoever in the actual transaction. Insist upon a written estimate even though this may cost you 1 or 2% of the value of the object. It is a very useful document to have if you are selling or exchanging jewellery; or, if you change your mind and decide to keep the jewellery, this document will be essential if you need to take out insurance.

Jewellers cited in this book:

Pietro Acuto, Via Cremona 22, I-15048 Valenza Po (AL)
Massimo Aloisio, Via Divisione Torino 47, I-00143 Roma
Giuliano Ansuini, Via di Monserrato 34, I-00186 Roma
Filippo Biffani, Via Cassia 837, I-00189 Roma
Federico Buccellati, Via dei Condotti 31, I-00187 Roma
Cafiso & Roda, Circonvallazione Ovest 14Ba1, I-15048 Valenza Po (AL)
Capuano di Via Veneto, Via Veneto 102, I-00187 Roma
Roberto Celotti, Via Irta 32, I-25015 Desenzano del Garda (BS)
Maria Angela Crescimbeni, Via Cirillo 15, I-00197 Roma
Creso, Via Santa Rosa 32, I-35100 Padova
Damiani, Viale Santuario 46, I-15048 Valenza Po (AL)
Fratelli Deambrogio, Viale della Repubblica 5-H, I-15048 Valenza Po (AL)
Marcello Garzi, Via del Maspino 30, I-52100 Arezzo
General Export Jewellery, Via Paolo da Cannobio 12, I-20123 Milano
Nuccia Joppolo Amato, Via Paolo da Cannobio 2, I-20123 Milano
Roberto Mangiarotti, Via Cavour 12, I-15048 Valenza Po (AL)
Ermés Marega, Via C. Pisacane 10, I-15048 Valenza Po (AL)
Max Gioielli, Via del Castagnone 7, I-15048 Valenza Po (AL)
Claude Mazloum, Schupstraat 9/11, (B.P. 23/C), B-2018 Antwerpen
Stefano Michelangeli-Polimeni, Via B. Bruni 65, I-00189 Roma
Mikawa, Via Giusto Calvi 7, I-15048 Valenza Po (AL)
Fratelli Moraglione, Via Sassi 45, I-15048 Valenza Po (AL)
Simone Muylaert-Hofman, Nieuwstraat 36, B-9300 Aalst
Orolinea, Via R. Serra 78, I-48100 Ravenna
Rodolfo Santero, Via Neera 45, I-20141 Milano
Marina Selvi, Via delle Bermude 10, I-00121 Roma
Paolo Spalla (Ferraris & Co.), Viale Dante 10, I-15048 Valenza Po (AL)
Claude Wesel, Drève Richelle 9, B-1410 Waterloo

To the Reader:
Firstly, I want to thank you for having read my book to the end. I sincerely hope that you have learned something new about the world of jewels and jewellery making, for I think my explanations have been clear and precise. However, should you have questions regarding personal problems which, due to their particularity, have not been touched on in this book you may send your questions to me in Antwerp and I shall be happy to help you out. Please detail as clearly as possible your problem and what information and advice you need. You will receive your answer within five to six weeks, including any addresses that might be useful to you.

CLAUDE MAZLOUM, Schupstraat 9/11 (B.P. 23/C), B-2018 ANTWERPEN - Belgium

Please include:
— Your full name and address/business card if useful.
— International stamp coupons worth 7 pounds sterling or 12 US dollars.
— A self-addressed envelope (minimum 23×16 cms).

Illustration credits

(a=above; b=belove; l=left; r=right; c=centre)

Damiani front jacket photo, 6, 16a; Nuccia Joppolo Amato inside cover, 2, 97, 166; Marc Robcyns back flap photo; Photochrom back jacket photo, 72, 93, 159, 175; Heimatmuseum 5, 24, 139; Rodolfo Santero 8, 173; J. Hansen/Heimatmuseum 73, 76a; Hoge Raad Voor Diamant 10, 15, 16b, 17, 22a and bl, 38, 39, 40, 43, 44a, 45, 46, 47, 48, 62, 116, 118, 119, 177a; Capuano/A. Cattarinich 18; Jean Alleyn 22 br, 23, 29, 33a, 114b; Angel Salqado Bustos 56a, 57a; Hosser/Heimat-museum 25; Filippo Biffani, 26 (design), 32 (design), 64b (design), 96 (design), 111 (design); Adros Studio 27, 52, 76b, 100, 139c; Claude Mazloum 30, 31, 34, 49 (design), 56b, 57b, 60a, 68a, 69l, 70, 114a, 122, 127a, 150 (design), 155a; Photo Studio 2000 33b, 138: Moraglione 35; Mangiarotti 36b, 137; Pavan 36a; R. Dröschel/Heimatmuseum 44b, 60b; Buccellati/Stefano Ronchetti 65, 80; Charles Mazloum 68bl and br, 133; Tourism Authority of Thailand 69r, 127b, 134, 135b; Greber/Heimatmuseum 79; Simone Muylaert-Hofman/Van Speybroeck 84; R. Faedi 89; Ditmar Bollaert/Karel Moortgat 92; Damiani/Heimatmuseum 104; J. Abeler/Historic Museum of Wuppertal 108; Piemonti 110, 142; A. Estefan 123a; Metropolitan Museum of New York 123b; Marina Selvi 170a, 171a; J.-L. Hue 135a; Garzi 146, 147b; Ansuini 147a; Hoge Raad Voor Diamant/Simone Muylaert-Hofman 154; Orolinea 155b; Creso 162; Studio Tecla 170b; Cafiso e Roda 171b; Sergio Mantello 174; Michel Lefrancq 177b.